IMPERIAL CHINESE ROBES
FROM THE FORBIDDEN CITY

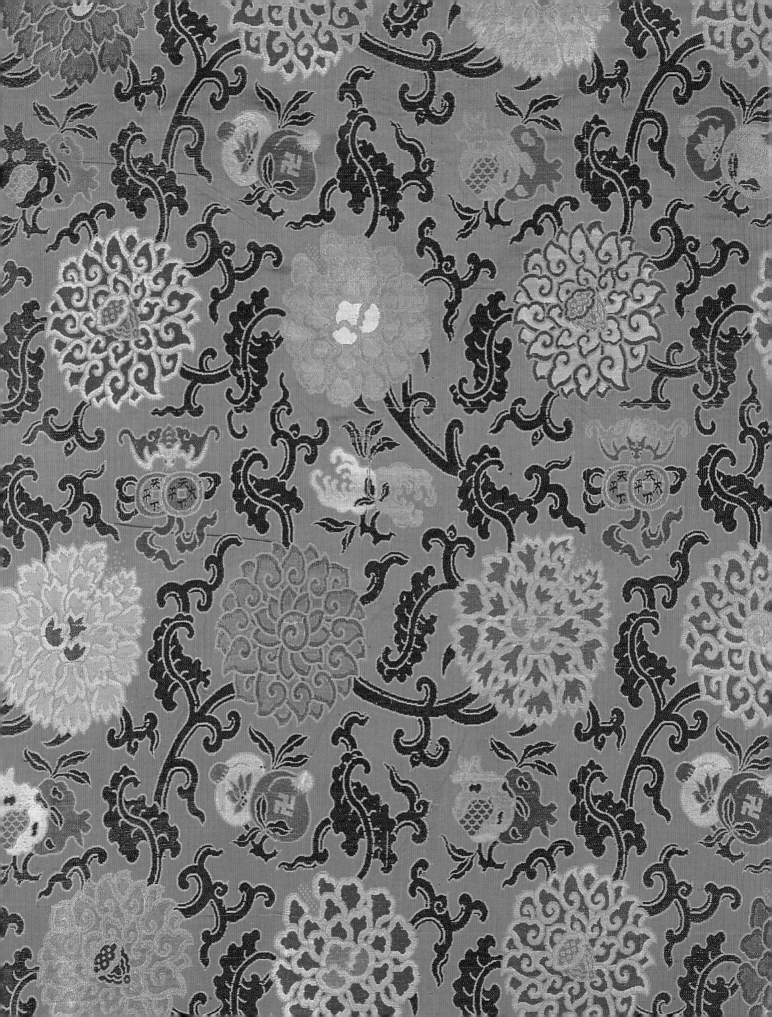

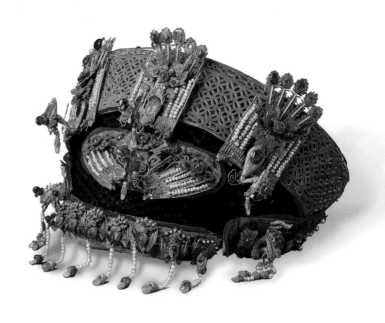

IMPERIAL CHINESE ROBES

FROM THE FORBIDDEN CITY

Edited by Ming Wilson
with the Palace Museum, Beijing

V&A PUBLISHING

First published by V&A Publishing, 2010
V&A Publishing
Victoria and Albert Museum
South Kensington
London SW7 2RL

ISBN 9781 85177 620 7

Library of Congress Control Number 2010937388

10 9 8 7 6 5 4 3 2 1
2014 2013 2012 2011 2010

Designer: Nigel Soper

FRONT JACKET ILLUSTRATION: Empress's informal robe (see p.73)
BACK JACKET ILLUSTRATION: Emperor's dragon robe (see p.40)
FRONTISPIECE: Bolt of brocaded satin (see p.102)
TITLE PAGE: Empress's festive headdress (*dianzi*) (see p.49)
CHAPTER OPENERS:
p.8 Map of the Forbidden City
p.12 Prince's festive robe (see p.42)
p.20 Empress's winter festive hat (see p.49)
p.60 Painting of Qianlong emperor wearing ceremonial armour, 1739
 Palace Museum, Gu008761
p.66 Empress's informal robe (see p.73)
p.98 Length of velvet (see p.107)
p.112 Woman's festive robe (see p.117)

Printed in Italy

V&A Publishing
Victoria and Albert Museum
South Kensington
London SW7 2RL
www.vandabooks.com

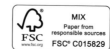

FSC
www.fsc.org

MIX
Paper from
responsible sources
FSC® C015829

CONTENTS

FOREWORDS

THE FIRST STAGE of a joint project between the Palace Museum in China and the Victoria and Albert Museum in the UK is taking shape. The exhibition *Imperial Chinese Robes from the Forbidden City* will travel abroad, and people from other parts of the world will see a clothing culture that was unique to ancient China. This unprecedented event will be followed by an exhibition of Indian art drawn from the V&A collection in the Palace Museum galleries in 2013, to which we look forward with great delight.

These exhibits are selected from the tens of thousands of textile items in the Palace Museum, and reveal how members of the imperial family were attired on both formal and informal occasions. The clothing system was a significant aspect of Chinese tradition. The dresses and accessories worn by Qing dynasty emperors and empresses represented the revered concept of order and hierarchy. The Qing rulers wore official dress at important rituals and state assemblies; festive dress was for festivals and celebrations; travelling dress for hunting or touring the provinces; the suit of armour for military occasions; regular dress for daily routine; and informal dress for family time. These different categories of dress are well represented in the exhibition.

Each robe is a beautiful artefact that reminds visitors of a glorious age. The choice of pattern and colour held profound meanings. The Twelve Symbols on the emperor's court robe symbolized his supreme authority, while nine dragons represented the highest number fit for head of the nation. The bright yellow colour was the prerogative of the emperor and empress. The patterns on informal dresses carried auspicious messages, which everyone at that time would have recognized.

The robes are made from colourful, beautifully woven silk. The textile mills in Nanjing, Suzhou and Hangzhou produced twill, gauze, satin, damask and brocade of the richest varieties and most exquisite designs; the choice selection of fabric materials for the exhibition reveals the extremely high standard of the imperial mills.

The history of Chinese clothing culture is several thousand years old, and Qing court costume is one splendid chapter.

It is our sincerest wish that the exhibition is a great success!

ZHENG XINMIAO, DIRECTOR,
PALACE MUSEUM

中国故宫博物院与英国维多利亚和阿尔伯特博物馆首次合作的交换展览已拉开序幕。应英国维多利亚和阿尔伯特博物馆之邀，"紫禁城皇家服饰展"将走出国门，向世人展示中华民族独具特色的古代服饰文化。而维多利亚和阿尔伯特博物馆馆藏的文物精品，也将于2013年在故宫午门展厅展出。我们为此感到由衷的高兴！

中华服饰是中华民族传统文化的重要组成部分，清代帝后冠服作为最具宫廷特色的一部分，是彰显皇家身份地位的物质载体，也是"贵贱有级，服位有等"的等级制度的体现。清代帝后在重大典礼和大的祭祀活动时都要着礼服；一般的典礼、重大吉庆及时令节日等活动穿吉服；出行围猎、巡幸则有行服；在军事活动中，最能显示皇帝军威的是戎服；在处理一般政务时，穿常服；燕居宫廷时着便服；遇雨雪天，则备有雨服。皇帝的礼服、吉服、常服、行服、戎服、便服和后妃的礼服、吉服、便服以及相配套的饰品，在这次展览中均可以看到。

一件件华丽精美、风格迥异的袍服，让人遐想起往昔的辉煌。皇家服饰从纹饰到颜色的使用，有着独特的审美情趣，同时蕴涵着深刻的寓意及丰富的内涵。礼服上日、月、星辰、山、龙、华虫、宗彝、藻、火、粉米、黼、黻十二章纹样，是皇权的象征；吉服中九条龙的纹饰，蕴涵着皇帝九五之尊的帝王之躯；明黄色袍服又是皇帝、皇后所专用不可僭越的标志；而便服中的图案纹饰，以象征、寓意、比拟的手法，无不渗透着吉祥寓意，虽然是人们所知所见的图案，却表达了一定的社会审美意识和生活理想。在中国数千年服饰文化史中，清代宫廷服饰是其中光彩夺目的一页。

这些织造精美、色彩富丽的清代服饰，是以华丽柔软的丝绸面料做成。绫、罗、绸、缎、纱、锦，绚丽多彩的织物，正是南京、苏州及杭州等江南织造工艺水平的体现。其品种之多，内容之丰富，技艺之精美，款式之绚丽，风格之多样，堪称无与伦比。展览中为数不多的十几件匹料，织造工艺精湛，色彩斑斓，光华熠熠，展示出皇家御用织造机构的最高水平。

此次展品是北京故宫博物院从馆藏十几万件的织绣文物中遴选出来的精品，品种齐全，可全方位了解清代帝后的服饰制度，也是对清代帝后吉庆典礼、政治活动、宫廷生活的真实写照。

衷心祝愿展览取得圆满成功！

故宫博物院院长
郑欣淼

THIS BOOK ACCOMPANIES the first exhibition in Britain to present costume, textiles and accessories from the unique collections of the Palace Museum, Beijing. The Victoria and Albert Museum is delighted to host this memorable exhibition, *Imperial Chinese Robes from the Forbidden City*, and this generously illustrated catalogue, are tangible results of growing professional contacts between our two museums.

The design and production history of the unique garments included in this publication, and their place in Qing dynasty court life, is vividly conveyed in a series of illuminating essays by Palace Museum curators Yan Yong, Ruan Weiping, Zhang Qiong and Yin Anni, without whose research and erudition our project could not have been achieved. I very much want to thank Director Zheng Xinmiao and the staff of the Palace Museum for their whole-hearted support as we have worked together. The Chinese Embassy in London, led by Ambassador Liu Xiaoming, and previously by Ambassador Fu Ying, has also been steadfast in encouraging us to mount this ambitious exhibition. The curators, conservators and exhibition teams of our two museums deserve special congratulations for their tireless work. They have taken responsibility for selecting, preparing, describing and transporting a remarkable group of objects, including robes and accessories worn by the Emperor himself. We are indebted to Lady Keswick and Sir David Tang for their generous support of the exhibition.

Textiles and dress reveal much about the official and personal lives of those who wear them, and these magnificent costumes evoke a world that has disappeared, the vast complex in the centre of Beijing that was both residence and workplace for the imperial household. The survival of these items of dress in the former Imperial Palace in Beijing is fortunate, since it makes an important element of China's past accessible to those eager to know more. In addition to the costumes borrowed for the installation, we are also very pleased to have the opportunity to show remarkable lengths of silks and satins woven for the Imperial Household in the great textile manufactories of Nanjing, Suzhou and Hangzhou, far to the south of the capital. By agreeing to lend these exquisite materials, the Palace Museum has enriched the display of finished costumes with a rare and fascinating insight into the close attention that was paid to commissioning and producing the outfits required by the imperial household.

As part of the V&A's long-standing commitment to collecting outstanding examples of art and design in various media, we have expanded our holdings of textiles and fashion over many years. Dress displays have long been an enduringly popular part of our China gallery, with our world-renowned collection of lavishly embroidered silk robes attracting particular attention. In common with other V&A exhibitions, *Imperial Chinese Robes* is intended to inspire designers and students in their creative endeavours. A superlative selection of precious costume and accessories has been graciously lent to us for this very special exhibition, giving our visitors an unrivalled opportunity to view China's imperial dress legacy, preserved for posterity in the Palace Museum.

MARK JONES, DIRECTOR,
VICTORIA AND ALBERT MUSEUM

Gate of Spiritual Valour

Palace of Earthly Tranquillity

Hall of Union

Palace of Heavenly Purity

Hall of Mental Cultivation

Hall for Worshipping Ancestors

Palace of Compassion and Tranquillity

Doorway of Heavenly Purity

The Council of State

Hall of Preserving Harmony

Hall of Central Harmony

Hall of Supreme Harmony

Hall of Literary Glory

West Flowery Gate

East Flowery Gate

Meridian Gate

INTRODUCTION

Ming Wilson

THE ROBES AND ACCESSORIES in this exhibition come from the Palace Museum in Beijing. The site on which the Museum stands today was known as the 'Forbidden City' prior to 1912; from 1644 to 1911 it was the residence and workplace of ten successive Chinese emperors. Throughout the year the emperor carried out a great variety of official tasks inside the Forbidden City, some practical, some symbolic, and some ceremonial. The clothes he wore were designed to suit the tasks he performed. When dynastic rule came to an end and a republic was proclaimed in 1912, the clothes and accessories of the emperors and empresses were accessioned by the Palace Museum as part of the national heritage.

The Forbidden City was the innermost part of Beijing city. It was rectangular in layout, 720,000 square metres in area, and was surrounded by a moat. Within this area were a staggering 8,700 separate buildings. Residents of the Forbidden City entered or exited via one of its four gates: the Meridian Gate (*Wumen*) in the south, the Gate of Spiritual Valour (*Shenwu men*) in the north, with the East Flowery Gate (*Donghua men*) and West Flowery Gate (*Xihua men*) on the two sides. To walk from the Meridian Gate to the Gate of Spiritual Valour would take approximately twenty minutes.

The Forbidden City itself was divided into two halves. The first half, at the southern end, was the Outer Palace. Three grand halls stood prominently along the central axis, the Hall of Supreme Harmony (*Taihe dian*) being the largest. Court assemblies were held in this hall, which was also used for other highly important occasions: an emperor's ascension to the throne, his birthday, his wedding ceremony, New Year and Winter Solstice celebrations, and sending off troops to battle. The emperor would perform the appropriate ceremonies in his full official attire.

Next came the Hall of Central Harmony (*Zhonghe dian*), a smaller building that served as an interim space before the emperor entered the Hall of Supreme Harmony. It was also the place where the emperor inspected the prayer texts to ensure their correctness. The third hall was the Hall of Preserving Harmony (*Baohe dian*), where feasts were held for Mongol nobles on New Year's Eve. After 1795 the hall was used to hold the imperial civil service examination, an event that took place once every three years.

To the east of the three grand halls was the Hall of Literary Glory (*Wenhua dian*), where learned ministers read classical texts to the emperor. On those occasions the emperor would wear his regular dress.

Continuing northwards, past the three grand halls, one would come to the threshold of the Inner Palace, where the emperor worked, ate and rested. No one, not even princes and nobles, was allowed beyond the Doorway of Heavenly Purity (*Qianqing men*), except those on duty or those summoned by the emperor. The Council of State (*Junji chu*), an extremely important and powerful policy-making unit set up in 1730, had an office just outside the Doorway of Heavenly Purity. This made it possible for the emperor to discuss urgent matters with the minister on duty at any time he liked.

Mirroring the layout of the Outer Palace, and along the same central axis, there were three halls in the Inner Palace, though these were on a smaller scale. They were the Palace of Heavenly Purity (*Qianqing gong*), the Hall of Union (*Jiaotai dian*) and the Palace of Earthly Tranquillity (*Kunning gong*). The first two Qing emperors, Shunzhi and Kangxi, lived in the Palace of Heavenly Purity. In 1723, the Yongzheng emperor chose to live in one of the palaces on the west wing, the Hall of Mental Cultivation (*Yangxin dian*), which all later emperors continued to use as their res-

idence. The Palace of Heavenly Purity became the venue for less formal banquets, as on Mid-Autumn Festival, and special parties, such as the feast given to the country's men and women over the age of seventy. These were celebratory occasions and the emperor would appear in his festive dress.

The other two halls were for the use of the empress. At the Hall of Union she met female members of the imperial family and Manchu noblewomen on important festivals to receive their greetings. The empress did not share rooms with her husband but had her own separate quarters. She lived in the Palace of Earthly Tranquillity, behind the Hall of Union. Flanking the three central halls were the east wing and west wing, with six palaces in each wing. These were the residences of the emperor's other wives, while the emperor's sons lived in buildings in the northeast and northwest sections. The Palace of Compassion and Tranquillity (*Cining gong*), still further to the west, was the residence of the empress dowager and other wives of deceased emperors. This palace was furnished with religious shrines, where the elderly ladies spent time praying for the well being of their children and grandchildren.

The emperor's residence, the Hall of Mental Cultivation, was situated in the west wing, and there he worked, sometimes on his own but more often with his ministers. Court assemblies at the Hall of Supreme Harmony were more formal in nature. Deliberations and decision-making were done in the Inner Palace.

Even though the empress and imperial concubines might have played a less important role in political life, a large proportion of imperial robes was provided for their consumption. The number of wives of each emperor varied. Kangxi (r.1662–1722) had the most wives, fifty-four in total, whereas Guangxu (r.1875–1908) had only three. Every year, each wife was given a certain amount of silk fabric and fur according to her rank. The empress was entitled to 150 bolts of silk of various types, twenty skeins of gold thread, a total of fifty-six catties of woollen thread, cotton thread and cotton wool, and ninety pieces of fur of various

types.[1] It is not clear whether the robes were given to her on top of this annual allotment.

The empress dowager's position was higher than that of the empress, due to Chinese respect for the aged. Each year she received 160 bolts of silk of various types, twenty skeins of gold thread, fifty-six catties of woollen thread, cotton thread and cotton wool, 400 buttons of sundry sizes, and 124 pieces of sable, sea otter and other fur.[2] Yet the empress dowager had very few official duties to perform. The Qianlong emperor's mother, for example, did accompany her son on his southern tours, but there was no prescribed travelling dress for the empress dowager. The implication was that female members of the imperial family would stay out of sight of provincial officials. Hence there was no need to stipulate what kind of clothes they should wear.

History took an unexpected turn in 1861. That year the Xianfeng emperor died leaving an only son aged six. The boy emperor Tongzhi's mother, Empress Dowager Cixi (1835–1908), was far from the docile woman that the male-dominated court had taken for granted. Instead of leaving the state affairs to close relatives or senior ministers, as tradition would have demanded, she took things into her own hands. Nominally Tongzhi sat on the throne, but it was Cixi who read all the ministerial reports and it was she who made the decisions. The dress code had not allowed for such an unprecedented situation. The official dress of an empress dowager was for New Year's Day or the emperor's birthday, not for ordinary days when she sat behind a curtain and listened to ministers reporting on government matters.

A solution was found in the informal dress category. The clothing regulations covered only the formal dresses; informal dresses had always been left to the personal preferences of the emperors and members of the imperial family. Wearing an informal robe while directing the country's affairs would have been unorthodox, but for an empress dowager to be involved in state affairs was in itself unorthodox. And since there was no precedent, Cixi could not be accused of breaking the dress code. The result was the

appearance of a large quantity of female informal dresses in the last quarter of the nineteenth century, all made from top-quality material and of exquisite workmanship.

As well as the Forbidden City, the imperial family had a second residence in Beijing, namely the Yuanming Yuan, or Garden of Perfect Brightness, also referred to as the 'Summer Palace'. The Forbidden City was built in the Ming dynasty and the Manchu inherited it when they became rulers in 1644. The Yuanming Yuan, on the other hand, was entirely the Qing emperors' creation. Situated twenty kilometres northwest of the Forbidden City, it was the favourite residence of the Yongzheng emperor and those after him, until it was burned down during the Second Opium War in 1860.

In August 1793, diplomatic gifts from King George III of Great Britain were installed, not in the Forbidden City, but in the Yuanming Yuan. Lord George Macartney (1737–1806), the first British ambassador to China, arrived in Beijing with his entourage, bearing gifts for the Qianlong emperor, only to find that Qianlong had gone to Chengde, a city 200 kilometres northeast of Beijing. Several members of the British embassy remained in the Yuanming Yuan to install the scientific and astronomical equipment, while Macartney and about seventy men proceeded to Chengde with the majority of the gifts. Setting out on 2nd September they reached Chengde seven days later.[3]

In Chengde there was another imperial summer retreat, the Bishu Shanzhuang (literally 'mountain mansion to escape the summer heat'), with the Mulan hunting grounds in the vicinity. Qianlong chose to hold his eighty-third birthday celebration in Chengde because the climate there was better than in Beijing. He also wanted to cultivate the goodwill of the Mongol nobles who attended the celebration, and he knew they would enjoy a hunting trip to Mulan. With the British envoys the emperor was on less certain ground. Macartney and his entourage were shown various scenic spots and were showered with gifts, but the embassy was too preoccupied with their charge to appreciate the somewhat arcane hospitality.

The Forbidden City continued to witness political turmoil in the nineteenth and twentieth centuries, and it is remarkable that over a period of 267 years, dresses worn by deceased emperors and empresses were carefully preserved in the Palace and not discarded. Clothes for grand state functions as well as simpler clothing items for daily wear tell the story of a vanished court life within the confines of the Forbidden City. And the beauty of Chinese silk itself explains why it has won over the world for nearly two millennia.

1 Qin and Yuan, p.116
2 Qin and Yuan, p.115
3 First National Archive, 1996, p.39

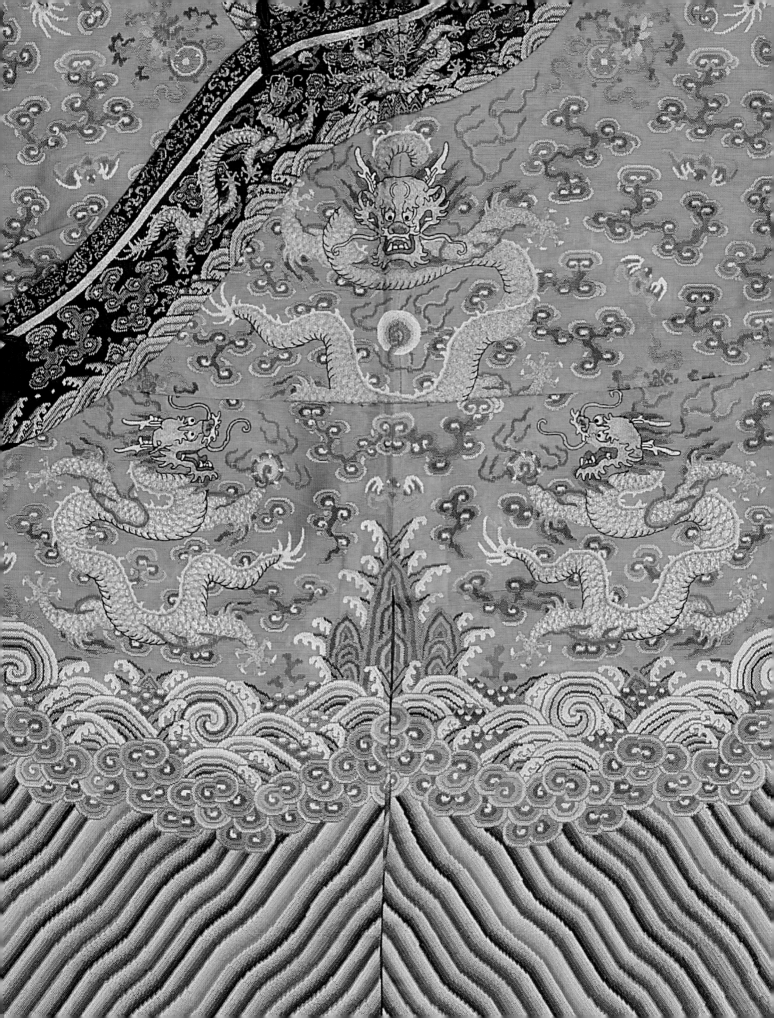

1. IMPERIAL DRESS IN THE QING DYNASTY

Yan Yong

IN 1644 THE MANCHU became rulers of China and established the Qing dynasty (1644–1911). The ruling élite of this conquest dynasty, whose origins lay in northeast China, remained acutely aware of its cultural distinctness. The ten successive Qing emperors, to a greater or lesser degree, fostered a separate Manchu identity different from that of the Han Chinese. The new Qing rulers brought their own writing system, created in the early seventeenth century, to the Chinese capital, making Manchu one of the two state languages of the dynasty. They also retained other pre-conquest customs, imposing some of them on the Han population. Several of these social habits are pertinent to dress and appearance, perhaps the best-known example being the braiding of men's hair. All adult males, of whatever ethnic origin, were required to adopt the Manchu hairstyle of a shaven forehead and a plait down the back.

Despite wishing to maintain Manchu separateness, the Qing ruling class nevertheless adopted several purely Chinese institutions, the civil service being one of them. Han Chinese men from the literate classes became a necessary part of this now Manchu bureaucratic enterprise, and when carrying out their official duties they had to wear a long robe with round neck opening and cuffs of horsehoof shape. The robe was fastened with a button in the middle of the collarbone, then the front half passed over to close under the arm on the right. This basic style remained throughout the dynasty, and marked a visual break with the preceding native Chinese dynasty, the Ming dynasty (1368–1644), whose vestimentary tradition of wide sleeves and voluminous garment shapes was now replaced by Manchu styles for male servants of the state, as well as the Manchu élite, including each reigning emperor and his family. Over time, there came some refinements to the dress code. However as in many other cultures, written statutes were no guarantee that the rules were always carried out. This accounts for discrepancies between the surviving objects and the prescriptive sources.

Precedent and hierarchy were the two fundamental concepts that gave rise to clothing regulations. By prescribing the correct type of dress to wear to suit the occasion, the emperors aimed to instil a sense of orderliness among their subjects, and good order relied on every man and woman observing their place in society. In 1759 the imperial dress regulations were codified. This was during the reign of the Qianlong emperor (r.1736–95), a sovereign mindful of how he would be seen by others, and who is known to have meticulously checked and commented on the robe designs drawn up for the imperial tailor.

There were five categories of formal wear – official, festive, regular, travelling and military – to be worn at the numerous state functions. Each category was further divided into winter and summer garments, for the comfort of the wearer, as the difference between extreme cold and extreme heat was substantial.

THE FIVE CATEGORIES OF DRESS

The emperor's official dress, a *chaofu*, translated as 'court robe', is of a particularly striking cut (plates 1, 2, 3 and 4). It is made up of two halves, top and bottom, and joined horizontally at waist level. It is ranked highest among the formal wear, worn during important rituals and court assemblies. The emperor's complete official ensemble worn with this pleated garment included a court hat (plate 7), a belt, a 'royal' coat, a necklace (plate 8) and a pair of boots (plate 9). In winter months he would also wear a fur coat.

Fig.1: Map of Beijing

Other members of the imperial family, as well as officials, would wear this type of robe, though none would be of such high quality as that of the emperor. Only the emperor's court robe could be woven or embroidered with the Twelve Symbols, described below.

On top of the court robe the emperor would wear a *gunfu* or 'royal' coat (plate 5). It was of knee length, fastened down the front, its sleeves reaching to the elbows and its cuffs straight-cut so that they did not cover the horse-hoof-shaped cuffs of the court robe worn underneath. It was invariably of dark blue, the winter version being lined with fur to protect the emperor from the severe cold. The shoulders, the chest and back were each adorned with a five-clawed dragon roundel embroidered in gold and coloured thread. Only the emperor's coat could be called a *gunfu*. The surcoats worn by the emperor's sons, though very similar in style and colour, were called *longgua*. The princes' surcoats also lacked the sun and moon motifs.

The colour of the court robe was of great importance. Certain grand sacrifices required the emperor's traditional yellow silk to be replaced: by blue at the Altar of Heaven, red at the Altar of the Sun, and 'moon white', a pale turquoise-blue, at the Altar of the Moon. Yellow was retained for the Altar of the Earth. These colours matched the ritual altar vessels (Fig.2) that were used during the lengthy ceremonies, a costly burden to successive Qing

emperors. The rituals also took their toll physically on those enacting the carefully choreographed ceremonies, and later in life the Qianlong emperor authorized his sons to stand in for him as he was fearful of failing to carry out the numerous movements correctly. The emperor's court necklace, too, would match the colour of the robe and vessels: lapis lazuli beads to match a blue robe, amber beads to match a yellow robe, coral beads to match a red robe, and turquoise beads to match a 'moon-white' robe.

Sacrifices to Heaven took place on Winter Solstice (22nd December of the Gregorian calendar). At the start of spring (4th February) the emperor offered sacrifices at the Altar of Agriculture, followed by sacrifices at the Altar of the Sun on Vernal Equinox (21st March). Sacrifices to Earth took place on Summer Solstice (21st June), and sacrifices at the Altar of the Moon on Autumnal Equinox (23rd September). The first month of each season was a time to pray to the ancestors, when seasonal fruits and vegetables were offered at the Imperial Ancestors Temple (*Taimiao*). Within the Forbidden City complex were the Hall for Worshipping Ancestors (*Fengxian dian*), shrines to Confucius and other ancient sages and saints, and shrines to Buddhist and Daoist deities. Before these shrines the emperor would light incense and pray on New Year's Day.

Last of all were the court assemblies, when the emperor met his ministers to listen to their memorials and reports. Traditionally, the emperor greeted foreign emissaries in the Hall of Preserving Harmony (*Baohe dian*) the day before New Year's Day. On those occasions he would wear a bright yellow court robe and a necklace made of opalescent white pearls.

The complete official court ensemble for the empress comprised a court robe with shoulder cape, a court hat and diadem headband (plate 14), sleeveless court coat, court skirt, three necklaces, collar ornament (plate 15), three pairs of earrings, a silk pendant and a pair of boots (plate 17). The female court robe was not cut in the same way as the emperor's, but was similar in shape to the straighter festive robes described below, with extra decorative silk insertions on the sleeves and along the shoulder seams (plate 10). Beneath this robe, the court skirt was largely hidden, its hemline just visible peeping out from beneath the robe, yet the law-makers took pains to specify that the upper half of the skirt should be made of red satin and the lower half of multi-coloured patterned satin (plate 12), a regulation

seemingly adhered to most of the time. The sleeveless court coat, too, covered most of the court robe, but at least the sleeves of the robe could be seen. The dragons, in profile, appeared vertically rather than horizontally, and were described as 'standing dragons' (plate 11). The silk pendant, a long piece of textile very similar to a modern necktie in shape, was worn hooked over a central button and draping down from the chest (plate 16).

The major ritual performed by the empress was to offer sacrifices at the Altar of Silkworms, an appropriate task for the head of the female population as weaving was traditionally considered a woman's job. On this occasion, which happened in spring, the empress would be accompanied by many of the imperial concubines and wives of the noblemen. The official dress for imperial concubines consisted of the same number of items, but, as with all these prescribed robes, hierarchy was indicated by variations in the materials used, the colours, the number of dragons and the patterns displayed on the dresses.

Festive dress, known as *jifu* (literally 'auspicious dress'), was less formal than the official dress, and worn on happy occasions such as festivals and imperial banquets. For events that lasted for extended periods of time, such as New Year, birthdays and weddings, the festive dress would be worn alongside the official dress. The vibrant colours did not symbolize natural forces or seasonal order, but were chosen to express joy and celebration. The bright yellow, however, remained the prerogative of the emperor, empress and empress dowager.

The emperor's festive robe was adorned with dragons and, later on in the Qing, with a striped wave motif at the hem (plates 19 and 21). Because of its predominant dragon design, the festive robe was also referred to as a 'dragon robe'. Stylistically, the festive robe can be distinguished from the court robe by its cut, being made up of two halves, left and right, and joined vertically in the middle. The festive robe has four slits – front, back and on the two sides; the court robe has none. A festive robe could be worn singly or with a 'royal' coat on top. The winter/summer change applied only to the festive hats.

The empress's festive dress could also be a dragon robe, almost identical to the emperor's, but with a small difference in the sleeves (plate 26). Like her official court robe, the empress's robe had extra sleeve inserts, a feature never seen on the emperor's robe. The number of slits on the robe

also varied: there were two slits on the female version but four on the male. Other styles of festive dress for the empress might have the striped water hem coupled with phoenix motifs instead of dragons (plate 25). Common to all types, however, are contrasting sleeves and a broad band applied around the neck and along the collarbone.

The emperor wore regular dress (*changfu*) on occasions when the court dress or festive dress would have been inappropriate (plates 32, 33, 34 and 35). Attired in regular dress, the emperor was still performing an official duty in front of others, and so this should not be confused with his informal dress. These duties included the anniversaries of the deaths of past emperors and empresses, the emperor's personal inspection of the preparations for the important ritual sacrifices, his periods of fasting in the Hall of Abstinence, and the announcement of posthumous titles for his deceased parents.

As supreme ruler of the country, the emperor was expected to be well versed in classical texts, and there was a tradition for learned ministers to read selected passages from the classical or historical texts to the emperor. The objective was for the emperor to remember the teachings of the ancient sages, and to learn from the successes and mistakes of past governments. Regular dress was deemed suitable attire for these occasions.

Regular dresses for the ladies of the court were similar to those of their male counterparts (plates 36, 37 and 38). Both men's and women's regular attire was usually made of fabrics of sober colours, plain or with subtle patterns; embroidery was seldom used. The regular robe could be worn singly, with a surcoat or with a jacket.

Travelling dress was worn by Qing emperors during excursions and when hunting. The full travelling outfit would include a robe, hat, jacket, riding apron and belt. The travelling dress was designed for horse riding and horseback archery, clearly indicating the original nomadic lifestyle of the Manchu people. The distinctive feature of a travelling robe is the asymmetric cut of the lower front, the right half being one Chinese foot shorter than the left half to facilitate movement (plate 30).

Among the Qing rulers, the Kangxi and Qianlong emperors were the most active; both made six surveying trips to the southern provinces. Qianlong also made official visits to the mausoleums of his ancestors in Shenyang, to Mount Tai, the most sacred mountain in China, and to Qufu, the birthplace of Confucius. Like his forebears,

Qianlong took pride in his riding and archery skills, and every year he went hunting in the Mulan imperial hunting grounds in Chengde, about 200 kilometres from Beijing.

There was no travelling dress or military dress set down in the regulations for empresses and imperial concubines; male military dress is discussed in Chapter 3.

MATERIALS, COLOUR AND MOTIFS

People attending a function wore the same style of dress, but a person's place in the hierarchy was revealed by variations in the materials used, by variations in colour, and by the motifs that embellished the silk's surface. Comprehensive descriptions were written in the official text, *Collected Statutes of the Great Qing* (*Daqing huidian*), as to what was reserved for the exclusive use of the emperor, followed, in descending order, by that for members of the imperial family, Manchu noblemen and other state officials.

How fur was employed on official dress brings home the point about different qualities of material. Seven types of skin were used in the production of fur coats, facings and trimmings – the higher the rank of the wearer, the better the quality of fur. The fur coat of the emperor was made of black fox or sable, its lining of bright yellow satin (plate 6). The heir apparent could use black fox with apricot yellow lining. The emperor's other sons wore sable with golden yellow lining, while other imperial princes wore blue fox. The remaining four types were, in descending order, mink, lynx, leopard fur and yellow fox, and were worn by noblemen of various ranks. State officials below the third rank were not allowed to wear fur at all.

Arguably the most conspicuous rank indicator, however, was colour. Bright yellow was reserved for the emperor (although he did wear certain other colours on particular occasions), empress dowager, empress, and first-rank concubine. Not even the heir apparent was allowed this particular bright yellow for his dress; his assigned colour was apricot yellow. The heir apparent could, however, use bright yellow on small items such as a belt or ribbons attached to a court necklace. Other sons of the emperor wore golden yellow.

From the robes that survive today, it is sometimes difficult to tell the different tones of yellow apart. At the present time, we do not know how the dyes were manufactured and applied to the silk. A book about basic industries, the *Tiangong kaiwu*, published just prior to the Qing conquest, notably omits details of dye recipes for Ming imperial yel-

Fig. 2: Porcelain vessels for Altars of Heaven, Earth, Sun and Moon
V&A: FE.99–1970, C.17–1968, C.483–1910, C.526–1910

low. It has been suggested that the Japanese Pagoda tree (*Sophora japonica*) may have provided the raw materials for the Qing bright yellow, supposedly a much brighter colour than the Ming shade. We can be sure, however, that the ancient Chinese philosophy of the Five Elements played some part in the choice of yellow as an imperial colour. Yellow was the colour for the centre (earth), the other four being red for south (fire), white for west (metal), black for north (water) and green for east (wood).

The court robe of princes of the first and second ranks was blue or dark blue, although some were bestowed special privilege to wear golden yellow. Princes of the third rank and below were not allowed to wear golden yellow. State officials of the fifth to ninth rank could wear only dark blue for their court robes. It is these dark blue robes that mostly survive today in collections outside of the Palace Museum.

As we have seen, among the female members of the imperial family, the empress dowager, empress and first-rank concubine wore bright yellow. The heir apparent's wife wore apricot yellow like her husband. High-ranking concubines of the emperor wore golden yellow, while lower ranking concubines and wives of princes wore 'incense yellow'. Apart from the above-mentioned womenfolk, no one was to wear yellow of any kind; they had to confine themselves to blue, dark blue or other appropriate colours.

In terms of pattern, the most sacred was the set of small motifs known as the 'Twelve Symbols' (see pp.18–19). These represented the emperor's utmost authority and were worn by him alone. The Twelve Symbols undoubtedly have

ancient roots: Ming dynasty emperors also seem to have had robes adorned with versions of them, and it may be that the Qing rulers, while preserving many of their own northern traditions, realized it was to their advantage to keep some of the Ming customs to reinforce a sense of continuity. The twelve motifs are the sun, moon, constellation, mountain, dragon, flowery creature, axe head, back-to-back *ji* characters, sacrificial vessels, waterweed, flame and grain. The sun, depicted with a three-legged bird inside it, and the moon, with a hare, are sometimes the easiest to spot on these robes as they are on the shoulder to the right and left respectively. These two beliefs – that a bird lives on the sun and a hare on the moon – had been prevalent for at least two millennia.

The presence of the sun, moon and constellation on the emperor's robe symbolized the emperor being in harmony with the heavens, while the mountain, dragon and flowery creature (depicted as a pheasant) represented things on earth. The axe head, back-to-back *ji* characters and sacrificial vessels were objects for ancestor worship. Lastly, the waterweed, flame and grain represented three of the Five Elements already discussed above.

Equally important was the dragon motif. This came in a variety of forms – front-face, profile and set within a roundel. The rules were so detailed that they spelt out how many dragons should be included, and on which part of the robe they should appear. Only the emperor's festive robe, and those of the empress dowager, the empress, the first-rank concubine and the heir apparent, could officially be called a 'dragon robe' (*longpao*). At the time the statutes were devised, robes for all other personnel were called '*mang* robes' (*mangpao*), although the animal looked very similar to the dragon. The *mang* robe was further divided into the five-clawed and four-clawed types. Princes, noblemen and state officials were assigned a certain number of *mang*, five-clawed or four-clawed, according to their rank, ranging from nine to five.

The clothing system of imperial China was viewed as an important constituent of a civilized society. Rulers recognized the unifying and harmonizing effects that a correct dress code might bring to their subjects. Each new dynasty introduced its own code to symbolize its ascendancy, and the Qing dynasty was no exception: the early emperors established and refined the dress code, while the Qianlong emperor regulated and enshrined it in the dynasty's statutes. A loosening of the dress laws was seen as symptomatic of decline.

THE TWELVE SYMBOLS

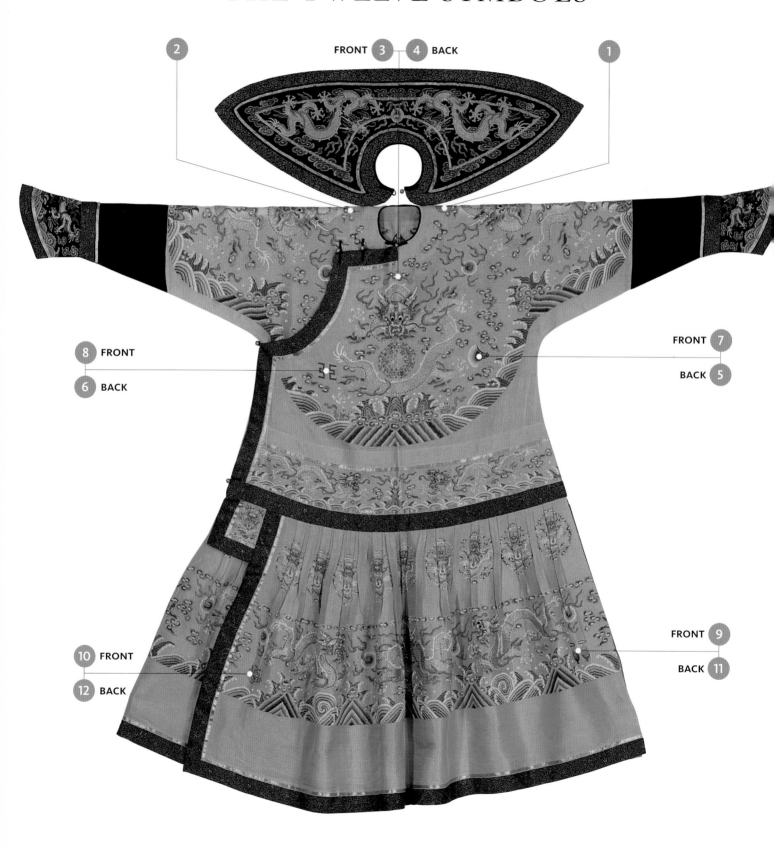

1 SUN

2 MOON

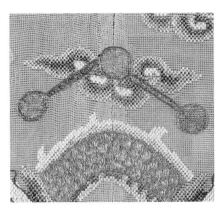

3 CONSTELLATION

4 MOUNTAIN

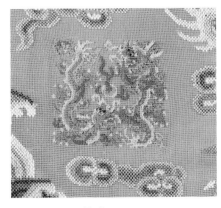

5 DRAGON

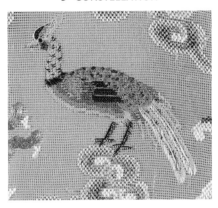

6 FLOWERY CREATURE

7 AXE HEAD

8 BACK-TO-BACK *JI* CHARACTER

9 SACRIFICIAL VESSELS

10 WATERWEED

11 FLAME

12 GRAIN

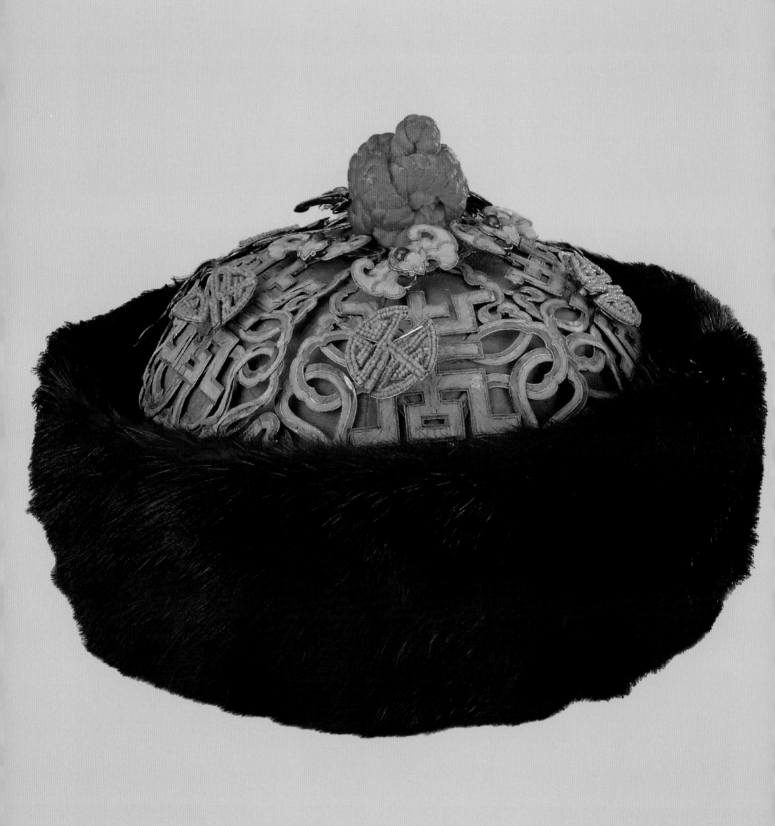

2. HATS FOR EMPERORS AND EMPRESSES

Ruan Weiping

HATS HAVE THE ABILITY to aggrandize the wearer and to make them stand out in a crowd. The Qing emperors and their empresses wore hats as an essential part of their ceremonial regalia and, like all monarchs in different places and across time, they must have learned to manage their headgear, to gauge its weight and to understand how far they could turn and tilt their heads without dislodging the hat. Four of the styles of formal dress for the Qing rulers, described in the previous chapter, had hats to match. All four types were further divided into winter and summer categories, with specific regulations governing the shape of each type and the materials used in their production.

COURT HATS

The emperor's winter court hat has an up-turned brim made of sable or black fox, a red silk cord fringe and a tiered finial. Each tier of the finial is embellished with four golden dragons and four small pearls, with larger pearls in between as well as at the top. Two ribbons fixed at each side of the brim secure the hat under the chin (plate 7). His summer court hat is made of straw, rattan or bamboo strips, covered with silk cloth and set with a tiny gold Buddha in the front and a dragon plaque at the back. Other features are the same as the winter court hat (Fig.3).

The court hat, part of the complete court ensemble, was worn on the most important and solemn occasions. The *Collected Statutes of the Great Qing* (*Daqing huidian*) provides detailed descriptions of two such occasions. The first was when the Shunzhi emperor (r.1644–61) ascended the throne. He had entered Beijing as a seven-year-old child under the protection of his regent and armies, and died of smallpox when he was only twenty-two:

The imperial processional insignia were displayed outside the Meridian Gate. The imperial throne was placed in the centre of the Gate of Supreme Harmony (*Taihe men*). A table was installed at the top of the Cinnabar Steps. Princes and noblemen assembled inside the Meridian Gate while Manchu and Han officials gathered outside. When the hour came the Master of Ceremony led the princes and noblemen into the Hall to take their places on the Cinnabar Steps. Next he led the officials through the side doors to take their places on the terrace. The Emperor entered the Hall of Supreme Harmony (*Taihe dian*). He was proclaimed supreme ruler.

The second example is a description of the emperor's sacrifice to Heaven. We can imagine the spectacle, with the silk of the clothes and the fringes of the hats rustling in the breeze, and the gold embroidery and hat finials catching the light:

On Winter Solstice Day sacrifice was offered to Heaven at the Round Mould. Five days before the ritual, officials from the Board of Rites inspected the animal offerings. Three days before the ritual, the Directorate of Imperial Sacrifices (*Taichang si*) sent the abstinence plaque and bronze figure to the Duan Gate. One day before the ritual, officials from the Board of Rites took the plaque and figure to the Hall of Supreme Harmony and placed them on the table set up on the Cinnabar Steps. On the day of the ritual, the emperor left the palace, read from the prayer tablets, lit incense and offered sacrifice.

The winter court hat for an empress is made of sable, with a red silk cord fringe and a tiered finial. Each tier has a golden phoenix set with pearls, and seven more gold phoenixes,

all set with large and small pearls, are attached to the red crown. Five strings of pearls hang down the back of the hat, suspended from another golden bird. The empress's summer court hat is made of dark blue velvet but is otherwise similar to that for winter wear. Court hats for imperial concubines have a two-tiered finial, five golden phoenixes on the red fringe, and three strings of pearls at the back (plate 13).

Offering sacrifice at the Altar of Silkworms was an important duty for the empress. According to the *Collected Statutes*, the event took place in two stages. On day one, at quarter to five in the morning, the Head of the Imperial Household Department and officials from the Directorate of Imperial Sacrifices request that the empress goes to the Altar. She wears her court dress and court hat. The processional insignia is displayed. At the Altar she feeds the silkworms.

On the following day, the Head of the Imperial Household Department sets up a dragon pavilion containing a golden sickle and yellow basket for the empress, a flowery pavilion containing silver sickles and orange baskets for the imperial concubines, and a flowery pavilion containing iron sickles and red baskets for the wives of the noblemen. The empress is invited to inspect the sickles and baskets. She then plucks the mulberry leaves and the court ladies follow suit.

This event was the only time that a woman officiated at an imperial ceremony, although women attended some other state rites and all family commemorations. Traditionally, in China, raising silkworms was women's work, and here the Manchu sovereigns, from an entirely different culture, were seen to be endorsing a wholly Chinese practice.

FESTIVE HATS

The emperor's winter festive hat is made of brown or purple sable or sea otter fur. It has a red silk cord fringe and the gold finial is set with one large pearl (plate 22). The summer festive hat is the same style as that for winter, except that it is made of straw, rattan or bamboo strips.

It is interesting to note that although the emperor wore his court hat when he offered sacrifice at the Altar of Agriculture, it was a festive hat that he wore when he enacted the ritual ploughing. This ceremony, the ploughing of furrows in a special enclosure near the Altar, was the only time the emperor appeared in full public view. The *Collected Statutes* describes the event as follows:

> Bells are rung at the Meridian Gate. The emperor leaves the palace and boards his carriage. The imperial

processional insignia are displayed but no music. Bells are rung at the Altar. The emperor offers sacrifice. Next the emperor changes into his yellow dragon robe and his festive hat to perform the ritual ploughing, accompanied by the princes and noblemen.

During Manchu rule, the empire's territory greatly expanded. Once the Qing armies had successfully subdued any remaining Ming opposition in the south, they continued to incorporate parts of northeast Asia by conquest. In 1724 the Qinghai region, located to the south of today's Republic of Mongolia, was subjugated. A ceremony to accept prisoners of war was performed at the Gate of Heavenly Purity (*Qianqing men*). The Yongzheng Emperor (r.1723–35) wore his dragon robe and festive hat for the occasion.

A festive hat was also considered appropriate at the betrothal ceremony of a princess. According to the *Collected Statutes*:

> On the auspicious day chosen by the Directorate of Astronomy (*Qintian jian*), the groom waits at the Gate of Heavenly Purity. One elderly minister whose wife is still alive would announce that Princess so and so is now betrothed to so and so. Music is played at the Hall of Preserving Harmony (*Baohe dian*) and at the palace of the empress dowager. The emperor takes his seat at the Hall

Fig. 3: Drawing of the emperor's summer court hat. V&A: 812–1896

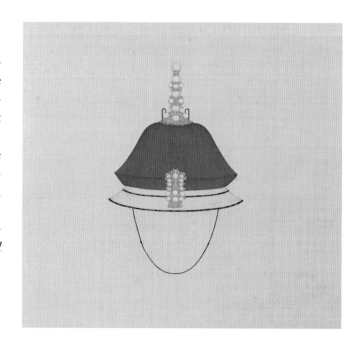

of Preserving Harmony. Under the guidance of a minister from the Directorate of State Ceremonial (*Honglu si*), the father of the groom and his clansmen prostrate themselves nine times on the Cinnabar Steps. Afterwards they enter the Hall and take their seats, and are offered tea and wine.

There is no distinction between winter and summer festive hats worn by the empress. These are made of sable, with a red silk cord fringe and topped by a pearl.

REGULAR HATS

Regular hats for the emperor, for both winter and summer, are similar to festive hats, but instead of a gold finial and pearl, they have a knot made of red silk cord at the top.

A major ritual utilized sacrificial vessels and animal victims and, before the ceremony itself, the emperor had to inspect these. For this inspection he would wear his regular robe and hat:

> Five days before the ritual the emperor visits the Animal Offering Unit. The imperial processional insignia are set up and music is played. The emperor leaves the palace; state officials kneel in front of the Meridian Gate. The emperor descends from his carriage at the south door of the Unit. Two officials from the Directorate of Imperial Sacrifices plus two censer bearers respectfully lead the emperor to the ox room, the sheep room, the deer room and the pigs' room.

Several of the rituals required the emperor to fast prior to the actual enactment of a ceremony, and on these occasions the emperor wore the regular robe and hat in the Hall of Abstinence:

> Praying for rain is performed annually in early summer. If no rain falls after that, prayers are offered to the heavenly gods, the earthly gods and the Star of Great Year (*Taisui*). If still no rain after seven days, prayers are offered at the Altar of Soil and Grain. If still no rain, another round of prayers to the heavenly and earthly gods and Taisui. If still no rain, the Grand Prayer for Rain is performed. One day before the ritual an official makes a petition at the Ancestors Temple (*Taimiao*). On the same day, at 10 o'clock in the morning, the emperor entered the Hall of Abstinence. No music, no clearance of passages, no imperial processional insignia.

THE EMPEROR'S TRAVELLING HAT

The emperor's winter travelling hat can be made of black fox, black sheep skin, dark blue velvet or dark blue woollen fabric. His summer travelling hat has a red fringe made of animal hair. Both have a red silk knot at the top like the regular hat.

Like his grandfather, the Kangxi emperor (r.1662–1722) before him, the Qianlong emperor (r.1736–95) made six extensive tours of China's heartland in the south. On each three-month-long tour, he inspected canal and dyke building projects, visited the commercial cities of the Yangzi Valley where the silks for his own clothes were produced, and prayed at sacred temple sites. In 1780, while in Nanjing, he visited the tomb of Hongwu, founder of the Ming dynasty, and showed his respect to the preceding ruler by bowing six times at the tomb. Qianlong must have travelled with his specially designated travelling clothes and hats.

The scale of the enterprise, from the point of view of the clothes and accessories that had to be packed and transported for the emperor and his retinue, must have been complex and extensive. The pictorial record of the emperor's southern journeys, in the form of a series of specially commissioned handscrolls, show how unsparing the planning and execution of these tours must have been.

INFORMAL HATS

There were no rules governing the shape or material of informal hats. Extant examples in the Palace Museum, which are numerous, show those for men to be in the form of a skull cap, usually fashioned from six pieces of embroidered silk sewn together, with a woven patterned silk border. At the top is a red silk knot from which hangs a red tassel (plate 59).

THE *DIANZI*

The *dianzi* is a particular form of hat or headdress worn by women. It is shaped like an inverted basket, the frame usually made of rattan strips or wire, covered with black silk lattice netting and dressed with all sorts of kingfisher feather and jewelled ornaments. It is not mentioned in Qing regulations, but there is graphic evidence to suggest that it is not an informal female hat. Imperial concubines frequently wore the *dianzi* with their festive dresses. Since the festive hat was required by regulations to be made of sable, we can perhaps speculate that female members of the imperial family created the *dianzi* for festive occasions in summer.

EMPEROR'S OFFICIAL DRESS AND ACCESSORIES

1. EMPEROR'S WINTER COURT ROBE
Blue satin with woven pattern, brown sable
Kangxi reign period (1662–1722)
Gu44831

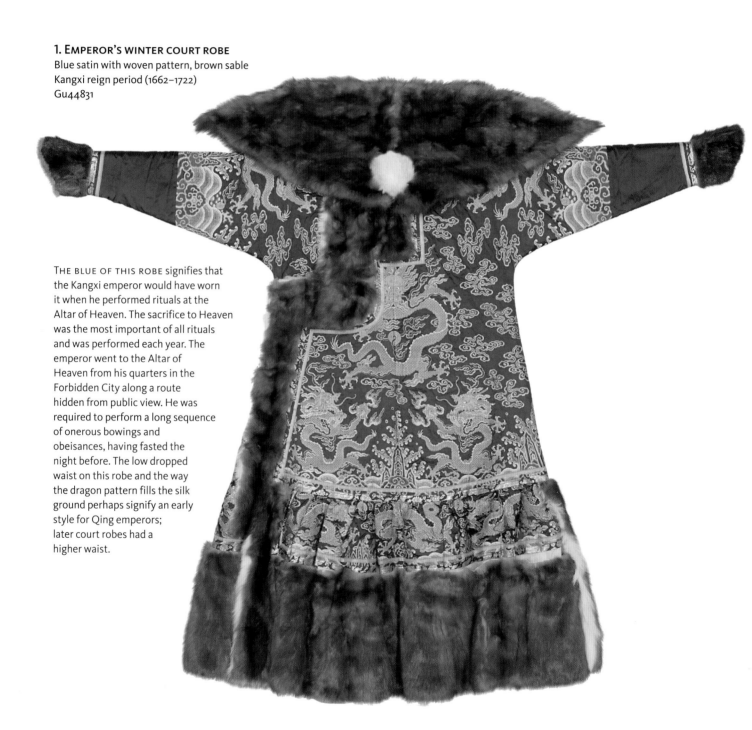

THE BLUE OF THIS ROBE signifies that the Kangxi emperor would have worn it when he performed rituals at the Altar of Heaven. The sacrifice to Heaven was the most important of all rituals and was performed each year. The emperor went to the Altar of Heaven from his quarters in the Forbidden City along a route hidden from public view. He was required to perform a long sequence of onerous bowings and obeisances, having fasted the night before. The low dropped waist on this robe and the way the dragon pattern fills the silk ground perhaps signify an early style for Qing emperors; later court robes had a higher waist.

2. EMPEROR'S SUMMER COURT ROBE
Bright yellow gauze with embroidered pattern
Xianfeng reign period (1851–61)
Gu43476

RESERVED SOLELY FOR members of the imperial family, bright yellow was traditionally worn for sacrifices to Earth and for other grand occasions. By the nineteenth century, when this robe was made, the dragon and striped wave design had become formalized. A lobed arrangement at the top of the garment and a horizontal band below a series of small roundels on the skirt section became the standard patterning for these court robes. The open-work gauze weave of the background silk provides a grid for the coloured embroidery and the goldwork, while the dark blue edgings, cuffs and lower sleeves create a contrasting dark frame around the garment.

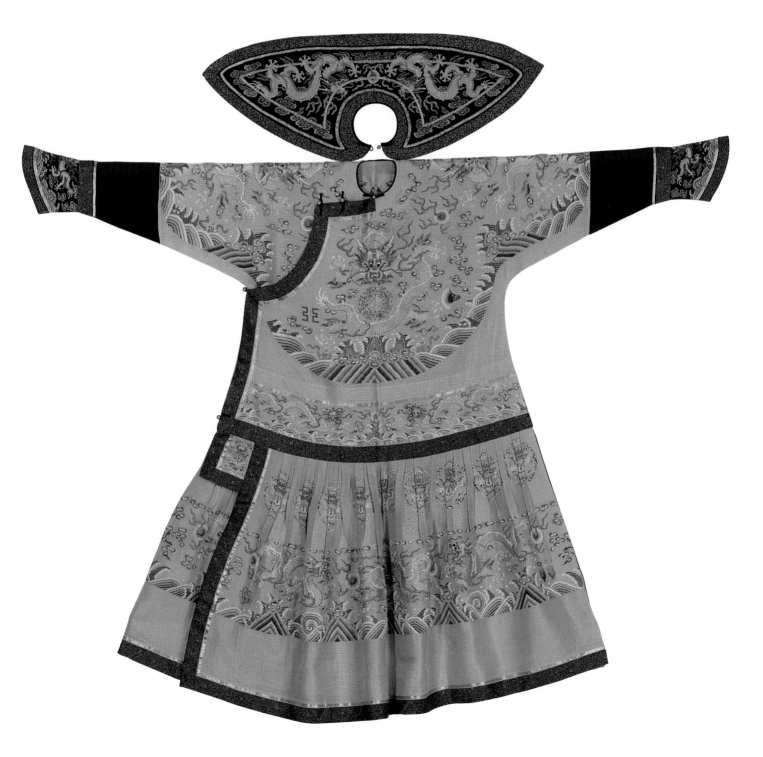

3. Emperor's winter court robe
Red satin with embroidered pattern, ermine
Jiaqing reign period (1796–1820)
Gu44994

Official court robes such as this are tailored from several distinct sections of cloth and are notably different in style from other, straight-seamed robes of the Qing dynasty. The upper section is joined at waist level to a pleated skirt, which is itself fashioned from two overlapping silk segments. The small flap to one side of the waist seems to serve no practical function, but may represent an outdated type of fastening. On the Vernal Equinox Day, the Jiaqing emperor wore this robe while performing rituals at the Altar of the Sun.

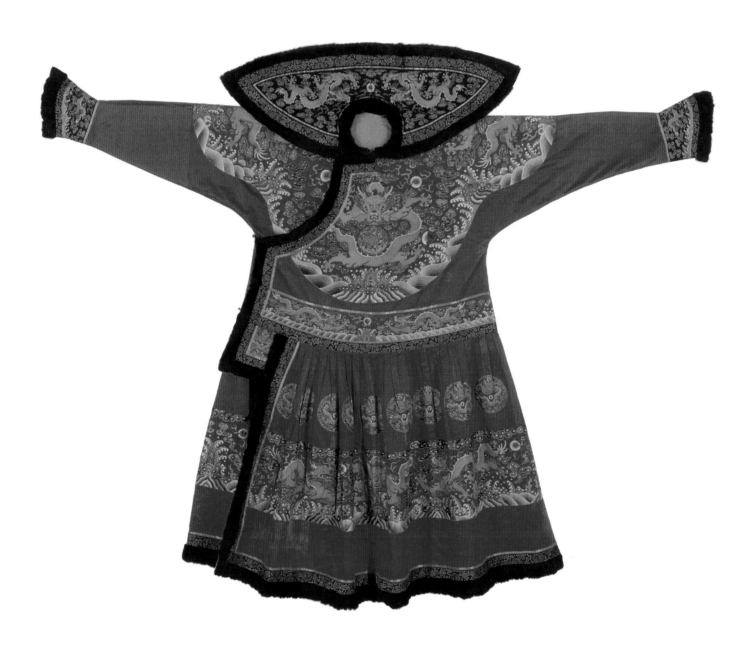

4. EMPEROR'S SUMMER COURT ROBE
Pale blue silk with tapestry-weave pattern
Guangxu reign period (1875–1908)
Gu44009

THIS PALE BLUE ROBE was worn by the emperor on the Autumnal Equinox when he performed rituals at the Altar of the Moon. The tapestry-weave technique from which it is made, while not unique to China, is certainly closely associated with this silk-producing country. Unlike embroidery, which is applied to the background silk, pictorial tapestry weave is incorporated into the silk on the loom. The weaver manipulates the coloured and gold threads across the silk's surface as weaving progresses and, when the silk is cut from the loom, the dragon and wave pattern is already complete.

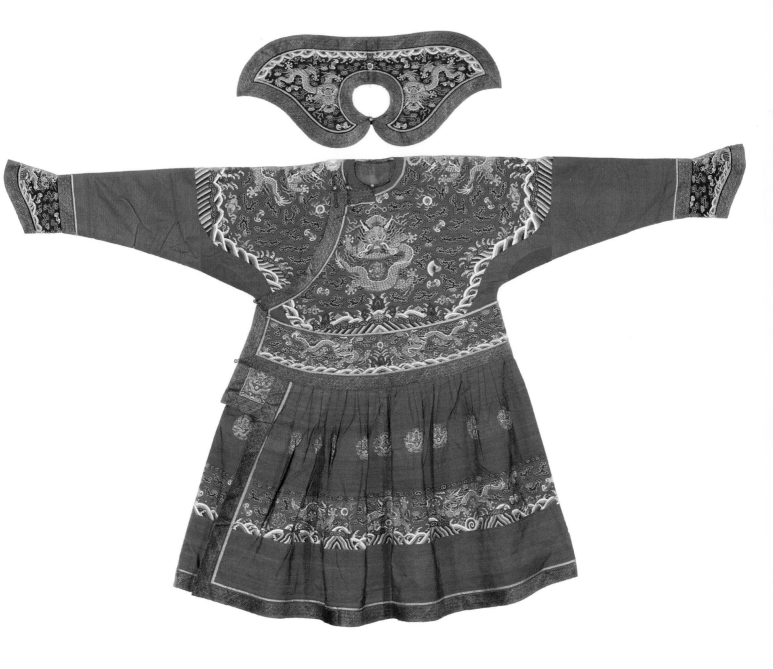

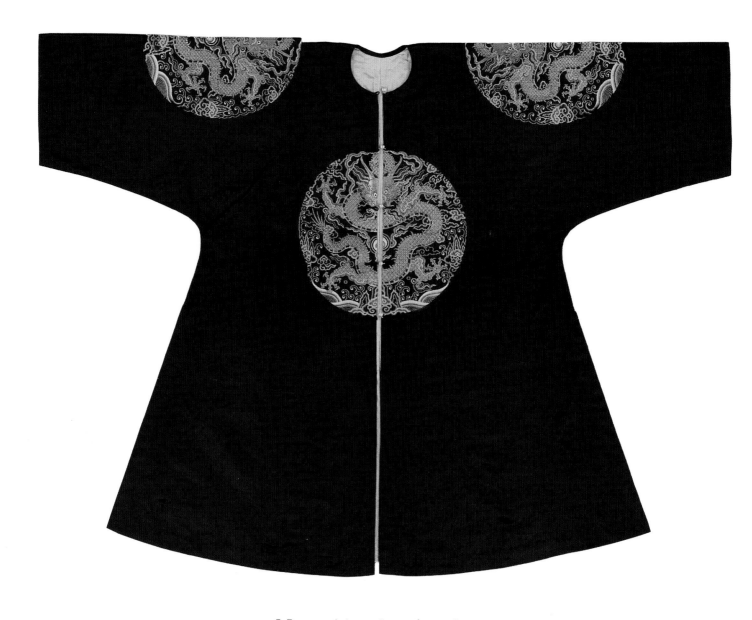

5. EMPEROR'S 'ROYAL' COAT (*GUNFU*)
Dark blue satin with woven pattern
Kangxi reign period (1662–1722)
Gu41811

A *GUNFU* IS A SURCOAT worn by the emperor
over the court robe. The layering of garments
and accessories adds bulk to the wearer, and the
gunfu, usually dark blue, is knee-length so that
the court robe could be seen below its hemline.
The regulations seem to stipulate its use with
the official court robe for certain ceremonial
occasions though imperial portraits frequently
depict the ruler without this overgarment. Four
dragon medallions decorate the coat, which is
fastened to waist level with spherical metal
buttons and silk loops.

6. Emperor's Fur Coat

Black fox, sable, yellow silk lining
Jiaqing reign period (1796–1820)
Gu44963

To protect the emperor from
the biting cold of north China
winters, he would wear a fur coat
over his court robe.

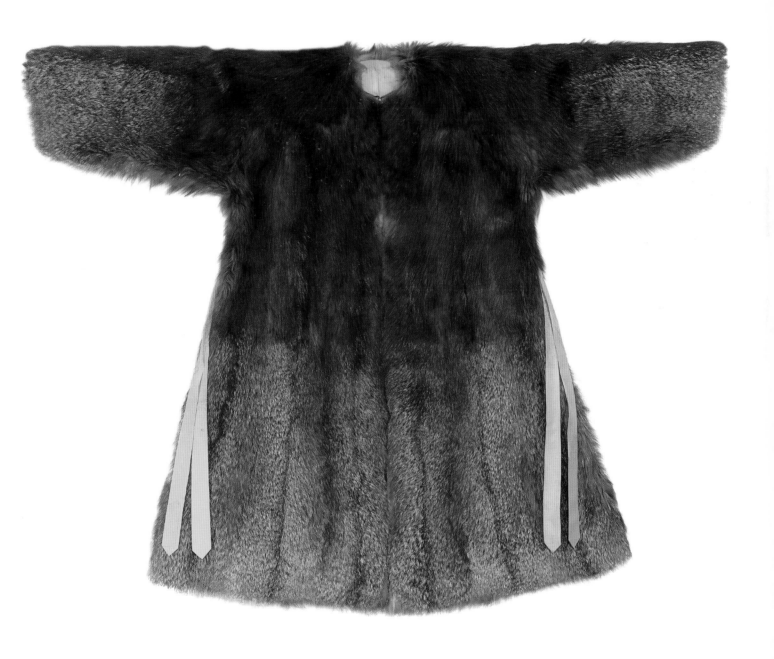

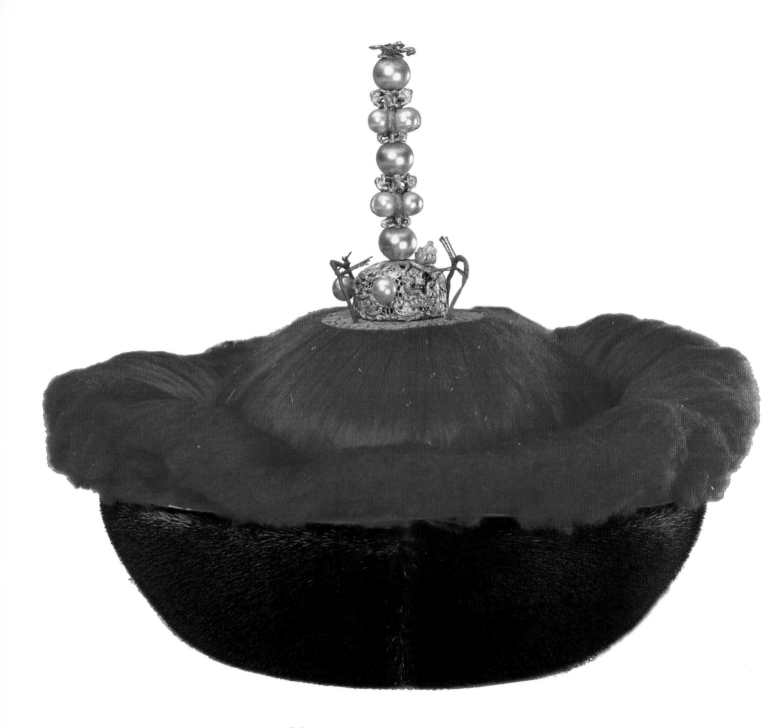

7. EMPEROR'S WINTER COURT HAT
Sable, pearls, gold, red silk floss
Qing dynasty (1644–1911)
Gu59739

HATS WERE A VITAL component of the regalia of
the Qing emperors and, like the Ming sovereigns
before them, they used them as immediately
recognizable markers of status. The brim of sable
indicates that this hat was for winter wear. This
valuable fur, which varies in colour, was much
sought after and large numbers of whole pelts
were required for the imperial wardrobe.

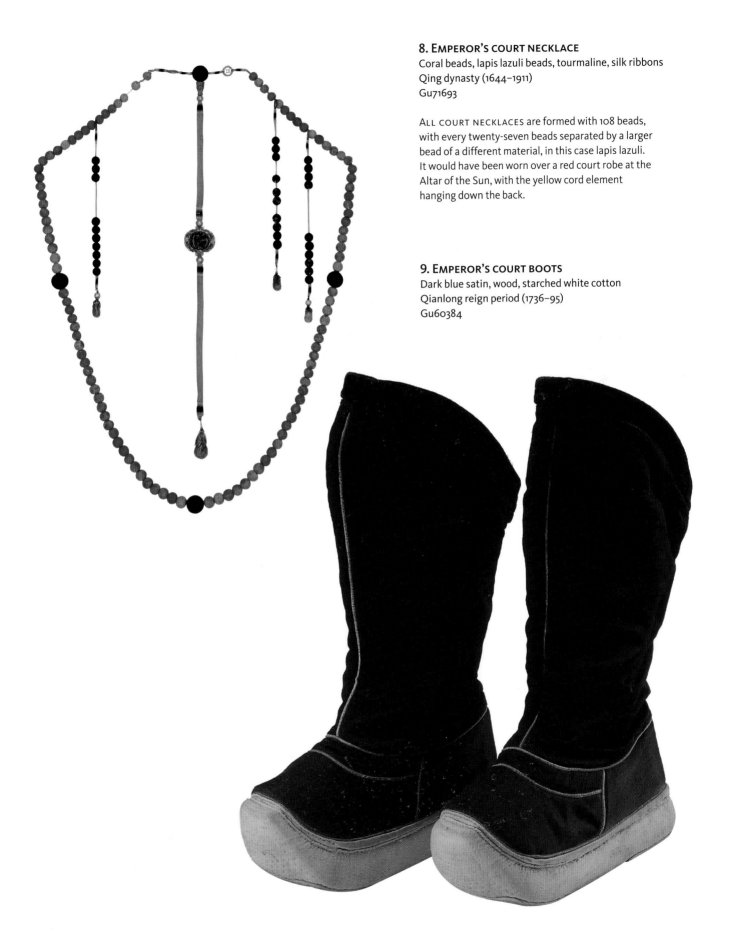

8. EMPEROR'S COURT NECKLACE
Coral beads, lapis lazuli beads, tourmaline, silk ribbons
Qing dynasty (1644–1911)
Gu71693

ALL COURT NECKLACES are formed with 108 beads,
with every twenty-seven beads separated by a larger
bead of a different material, in this case lapis lazuli.
It would have been worn over a red court robe at the
Altar of the Sun, with the yellow cord element
hanging down the back.

9. EMPEROR'S COURT BOOTS
Dark blue satin, wood, starched white cotton
Qianlong reign period (1736–95)
Gu60384

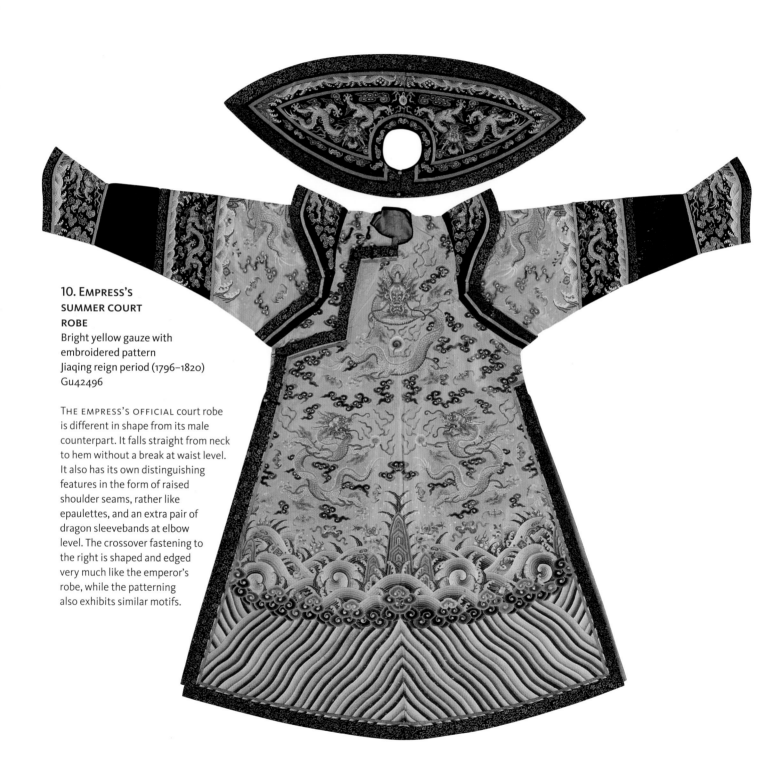

**10. EMPRESS'S
SUMMER COURT
ROBE**
Bright yellow gauze with
embroidered pattern
Jiaqing reign period (1796–1820)
Gu42496

THE EMPRESS'S OFFICIAL court robe
is different in shape from its male
counterpart. It falls straight from neck
to hem without a break at waist level.
It also has its own distinguishing
features in the form of raised
shoulder seams, rather like
epaulettes, and an extra pair of
dragon sleevebands at elbow
level. The crossover fastening to
the right is shaped and edged
very much like the emperor's
robe, while the patterning
also exhibits similar motifs.

11. EMPRESS'S SUMMER COURT COAT
Dark blue satin with embroidered pattern
Xianfeng reign period (1851–61)
Gu43483

THIS SLEEVELESS COAT was worn on top of the court robe and so the armholes are generously cut to allow for this. It is meticulously constructed of broad bands of silk that have been evenly folded to reveal a standing dragon on each pleat. Each of the three bands is a slightly different width, with the narrowest at the top and the widest towards the hem. Woven applied edgings in blue and gold trim the armholes, the front opening, waist, hem and one of the horizontal bands. The coat is front fastening and has buttons to waist level only. The lower part of the coat would therefore swing open to expose the court robe beneath, as well as the red lining of the coat itself.

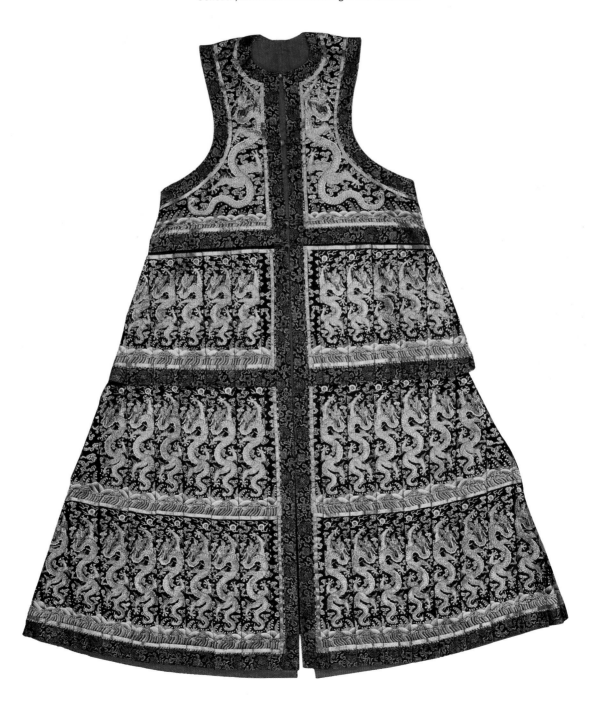

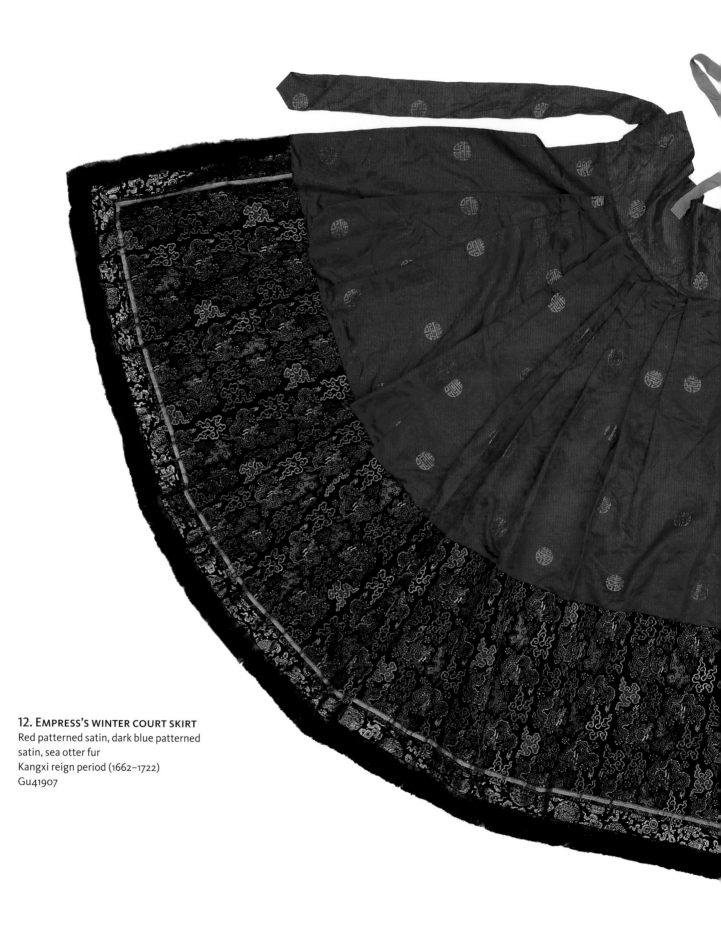

12. EMPRESS'S WINTER COURT SKIRT
Red patterned satin, dark blue patterned
satin, sea otter fur
Kangxi reign period (1662–1722)
Gu41907

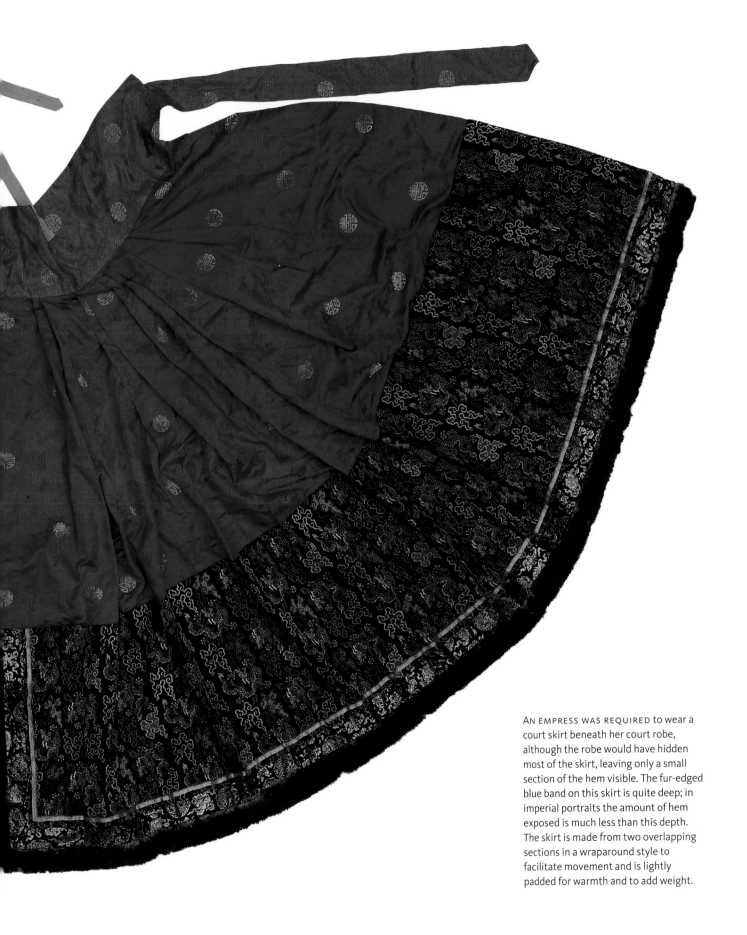

AN EMPRESS WAS REQUIRED to wear a court skirt beneath her court robe, although the robe would have hidden most of the skirt, leaving only a small section of the hem visible. The fur-edged blue band on this skirt is quite deep; in imperial portraits the amount of hem exposed is much less than this depth. The skirt is made from two overlapping sections in a wraparound style to facilitate movement and is lightly padded for warmth and to add weight.

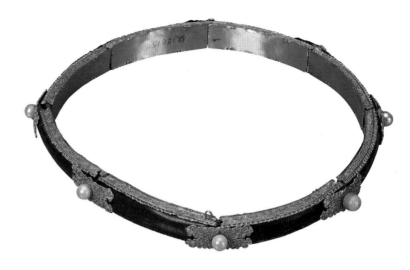

13. IMPERIAL CONCUBINE'S WINTER COURT HAT

Sable, pearls, gold, tourmaline, red silk floss
Qing dynasty (1644–1911)
Gu59671

A PHOENIX CROWN was the ceremonial headdress worn by the empress and imperial concubine with the full court dress ensemble. The sable brim is topped by a mass of red silk floss, and golden phoenixes are affixed to this as well as to the finial rising from the centre. The strings of pearls falling down the back of the hat remind us that this type of court attire would be viewed from several different angles as the participants bowed and turned according to the ritual movements set down for each ceremony.

14. IMPERIAL CONCUBINE'S DIADEM HEADBAND

Lapis lazuli, pearls, gold
Qing dynasty (1644–1911)
Gu12015

BEFORE PUTTING ON her court hat, the imperial concubine would secure her hair with a diadem headband. When she was fully dressed, the diadem would be partially visible across her forehead beneath the brim of her hat. Together the hat and diadem must have been cumbersome and heavy to wear. There are eight pearls set in gold plaques on this diadem; the diadem for an empress would have thirteen, as an indication of her higher rank.

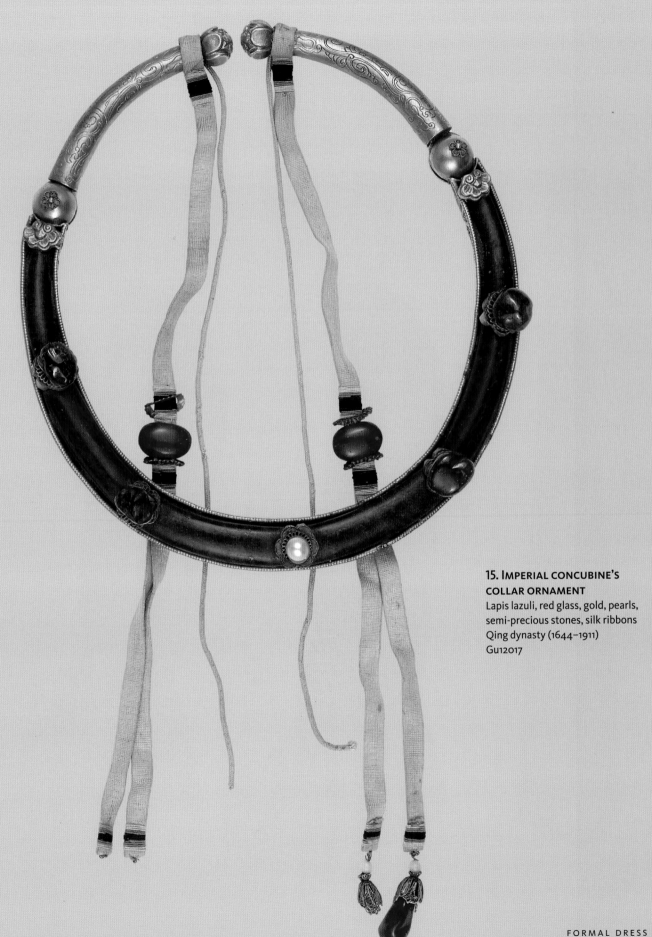

15. IMPERIAL CONCUBINE'S COLLAR ORNAMENT
Lapis lazuli, red glass, gold, pearls, semi-precious stones, silk ribbons
Qing dynasty (1644–1911)
Gu12017

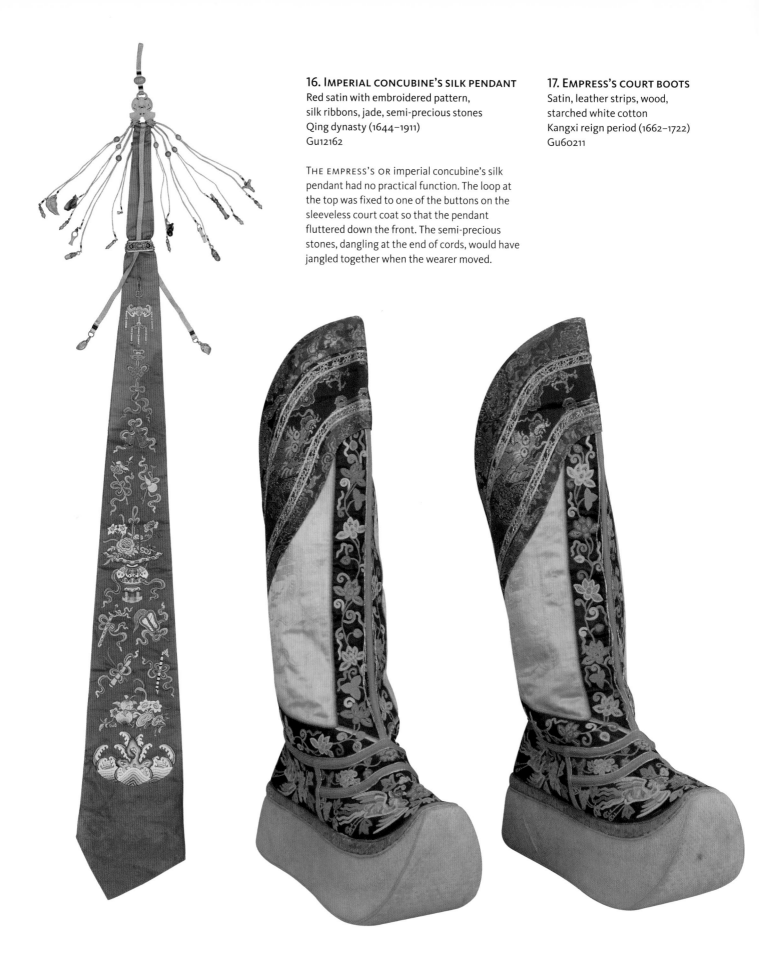

16. IMPERIAL CONCUBINE'S SILK PENDANT
Red satin with embroidered pattern,
silk ribbons, jade, semi-precious stones
Qing dynasty (1644–1911)
Gu12162

THE EMPRESS'S OR imperial concubine's silk
pendant had no practical function. The loop at
the top was fixed to one of the buttons on the
sleeveless court coat so that the pendant
fluttered down the front. The semi-precious
stones, dangling at the end of cords, would have
jangled together when the wearer moved.

17. EMPRESS'S COURT BOOTS
Satin, leather strips, wood,
starched white cotton
Kangxi reign period (1662–1722)
Gu60211

EMPEROR'S FESTIVE DRESS AND ACCESSORIES

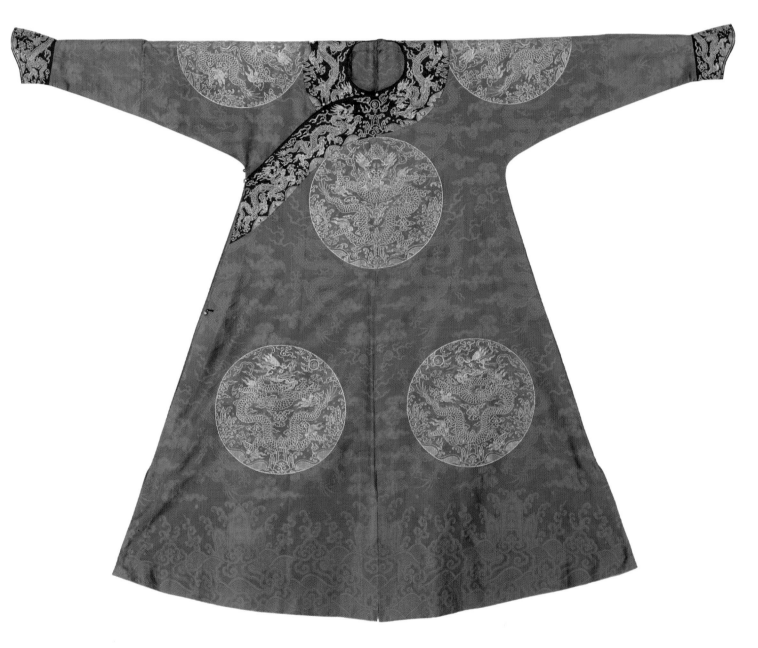

18. EMPEROR'S DRAGON ROBE
Brown gauze with woven and
embroidered patterns
Kangxi reign period (1662–1722)
Gu41765

THE EMPEROR'S FESTIVE DRESS was nearly always adorned with the dragon motif and so was called a 'dragon robe'. This example is of unlined gauze which has a small all-over pattern woven into it. Eight medallions containing dragons are embroidered onto the open-work gauze ground in metallic thread. The horsehoof -shaped cuffs and the trimmings applied to the neck and side opening echo the dragon motif on the main body of the garment and are fashioned from blue and gold silk especially designed and woven for this purpose. This garment, from the reign of the Kangxi emperor, does not yet exhibit what was to become a formulaic feature of these dragon robes, namely a deep hem of diagonal coloured embroidery referred to as *lishui* ('standing water').

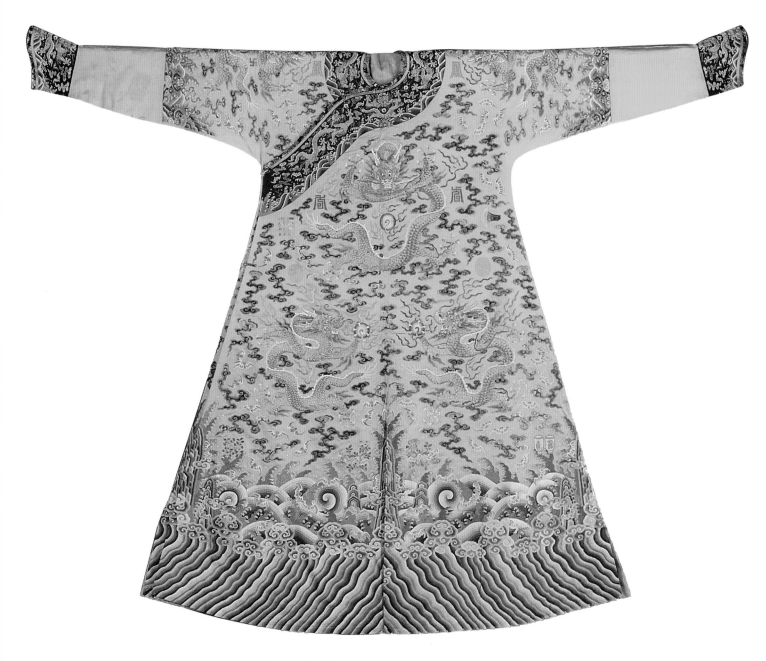

19. EMPEROR'S DRAGON ROBE
Bright yellow satin with embroidered pattern
Qianlong reign period (1736–95)
Gu41992

THIS IS A STANDARD example of the emperor's dragon robe from the
Qianlong reign period. It is embroidered with three dragons on the
front, three on the back and two on the shoulders, complete with five-
coloured clouds and the diagonal 'standing water' motif at the hem.

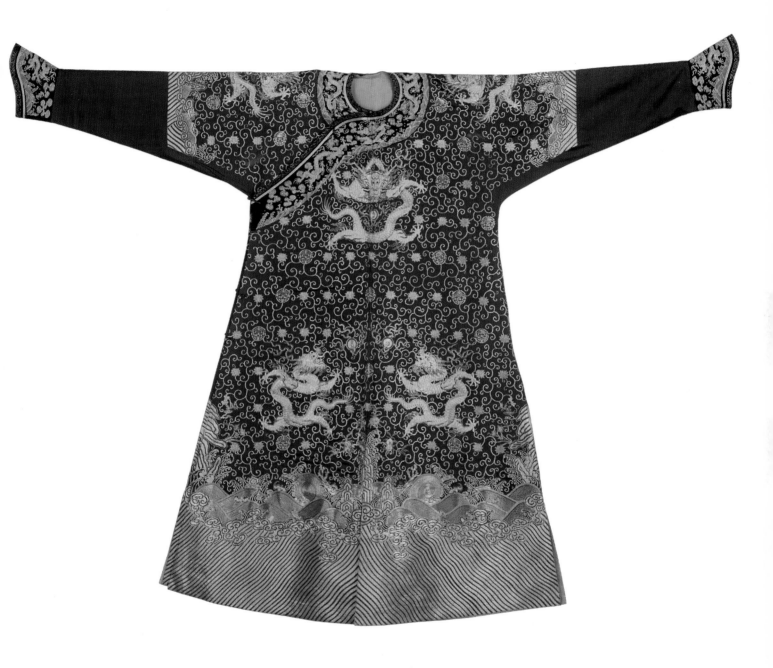

20. EMPEROR'S DRAGON ROBE
Brown satin with embroidered pattern
Qianlong reign period (1736–95)
Gu42548

THE DESIGN OF DRAGONS above waves is
brought to life by the skilful use of gold
and silver thread. The background is filled
with small lotuses.

21. Prince's festive robe
Apricot yellow silk with tapestry-weave pattern
Jiaqing reign period (1796–1820)
Gu42995

THE YELLOW COLOUR worn by a prince is described as 'apricot yellow', to distinguish it from the 'bright yellow' reserved for the emperor. The creature on this robe is described in palace documents as a '*mang*', although visually the *mang* is almost identical to the dragon. By the time this robe was made, the water pattern at the hem had become standard. Here it is in smooth floss silk thread in five colours, each of the colours shading from light to dark. Above the stripes are small and large rolling waves with a central tripartite mountain straddling the front seam of the robe.

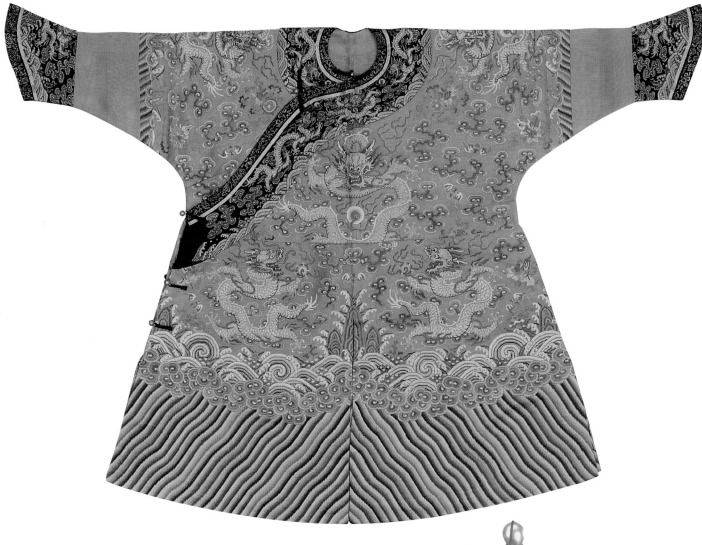

22. Emperor's winter festive hat
Sable, pearl, gold, red silk cord fringe
Qing dynasty (1644–1911)
Gu59707

SABLE WAS WIDELY in demand for trimmings and coats of all kinds. This soft pelt came from a weasel-like mammal living on the northern Sino-Siberian border; as a commodity of trade, it was frequently enmeshed in border rivalry between Russia and China.

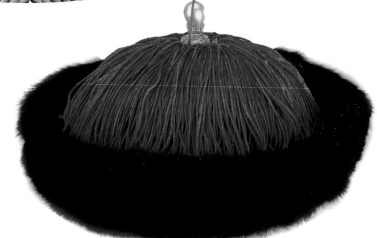

EMPRESS'S FESTIVE DRESS
AND ACCESSORIES

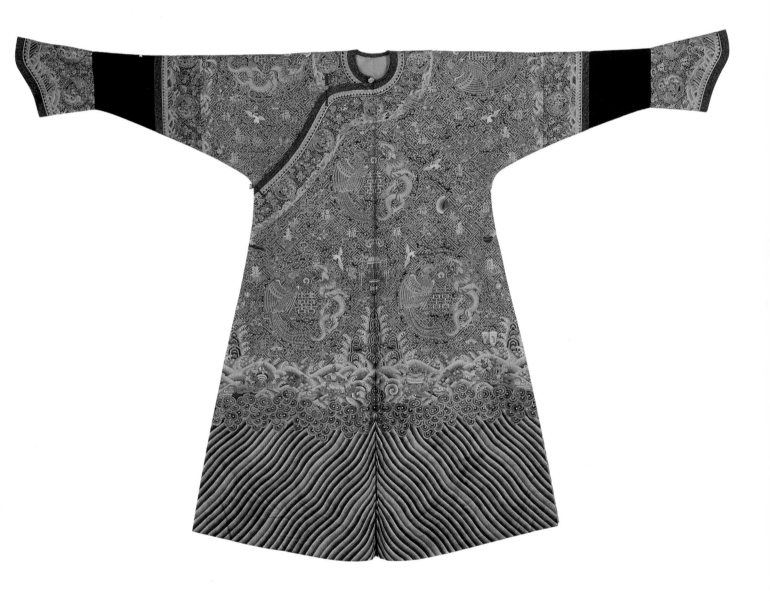

23. EMPRESS'S PADDED FESTIVE ROBE
Red silk with embroidered pattern
Guangxu reign period (1875–1908)
Gu44219

THIS ROBE IS EMBROIDERED with eight roundels, each incorporating a dragon, a phoenix and a double-happiness character. It was the wedding dress of Empress Jing Xiaoding (née Yehe Nara Jingfen), which she wore on her marriage to the Guangxu emperor in 1889. The brilliant mauve colouring on the striped water hem of this robe is likely to have been produced from

an aniline dye. The first synthetic dye, known as 'Perkin's purple' after the chemist who discovered it, had been produced in England in 1856. The 1862 International Exhibition in London made these new bright colours an instant success and soon the dyes were being exported abroad. We know from customs' reports that the dyes were being sent to China from at least 1871.

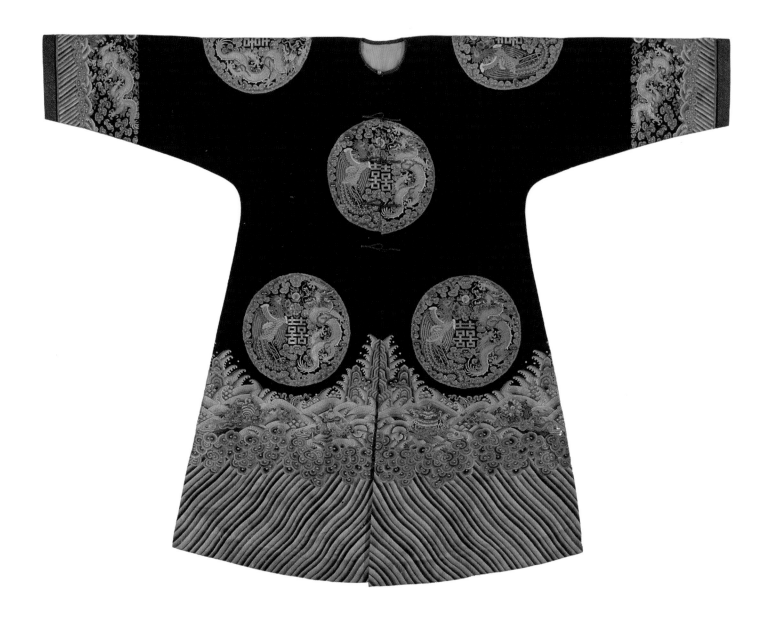

24. EMPRESS'S PADDED FESTIVE SURCOAT
Blue silk with embroidered pattern
Guangxu reign period (1875–1908)
Gu44332

THIS SURCOAT HAS exactly the same pattern, embroidered on blue silk instead of red, as the previous festive robe. It is slightly shorter than the red robe and would have been worn on top of it.

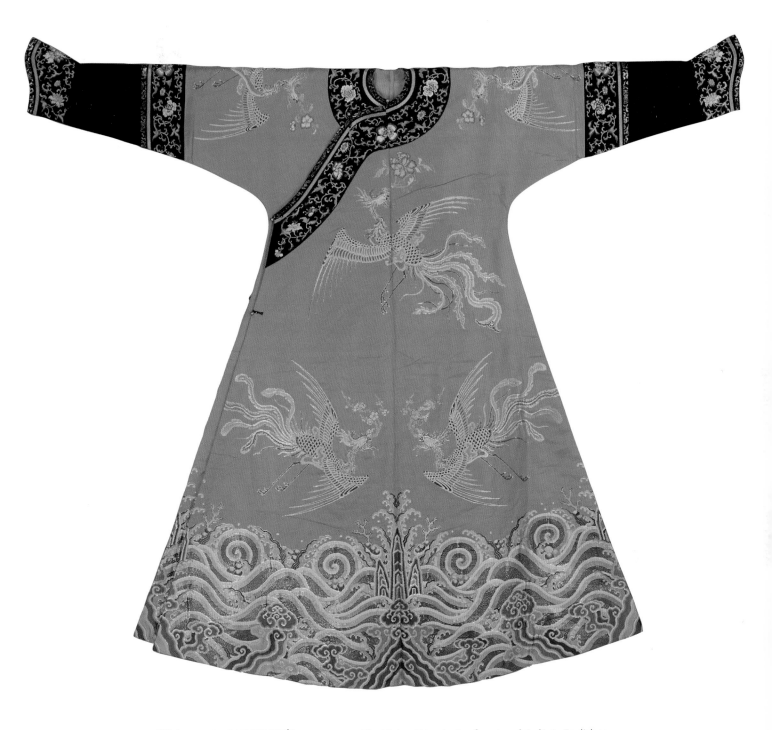

25. IMPERIAL CONCUBINE'S FESTIVE ROBE
Incense yellow satin
with woven pattern
Qianlong reign period (1736–95)
Gu42141

The bird on this robe is a *feng*, translated into English as 'phoenix', though a rather different bird from that of European myth. The Chinese version is a bird of good omen and was a symbol of the empress and high-ranking imperial concubines. Here, several phoenixes are superbly rendered, disposed in flight across the silk's surface. The rolling waves and tripartite mountain form a dense hem, and this density of decoration is matched on the upper part of the garment by applied sleeve bands, cuffs and neck edging in a contrasting colourway.

26. Empress's festive robe

Bright yellow gauze with double-sided
embroidered pattern
Qianlong reign period (1736–95)
Gu43496

A YELLOW SILK TAG on this double-sided robe says that
the sewing was done in 1853, yet the style and quality of
the embroidery belong to the Qianlong reign. It was a
fairly common practice to use fabric from old stock,
and it is likely that this robe was tailored for a
nineteenth-century empress from silk that had been
embroidered in the eighteenth century. The lengths of
silk would have been held taut and flat between two
beams while the embroidery was being executed.
Straight parallel stitches laid side by side predominate
on many Chinese robes, and here the embroiderer had
to ensure that the work on the reverse of the silk was of
the same quality as that on the front. It seems unlikely,
however, that the finished robe was meant to be truly
reversible; it was executed this way as a mark of skill.

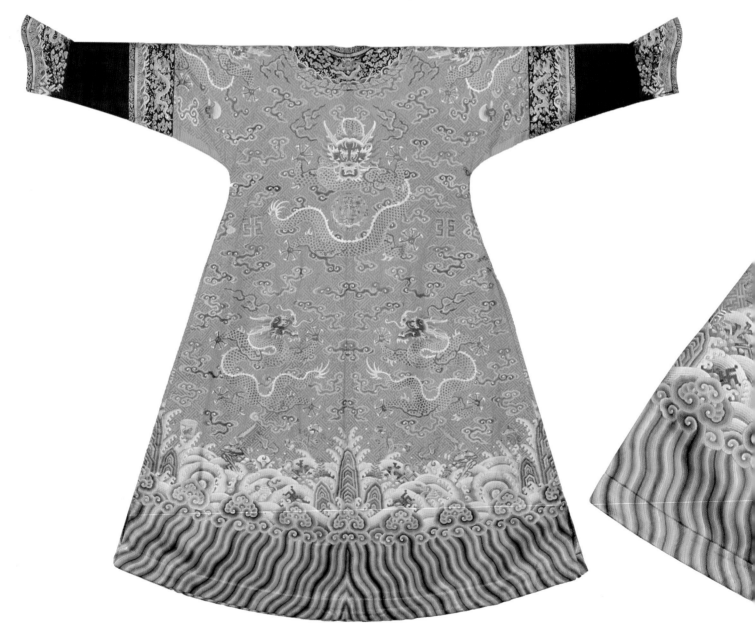

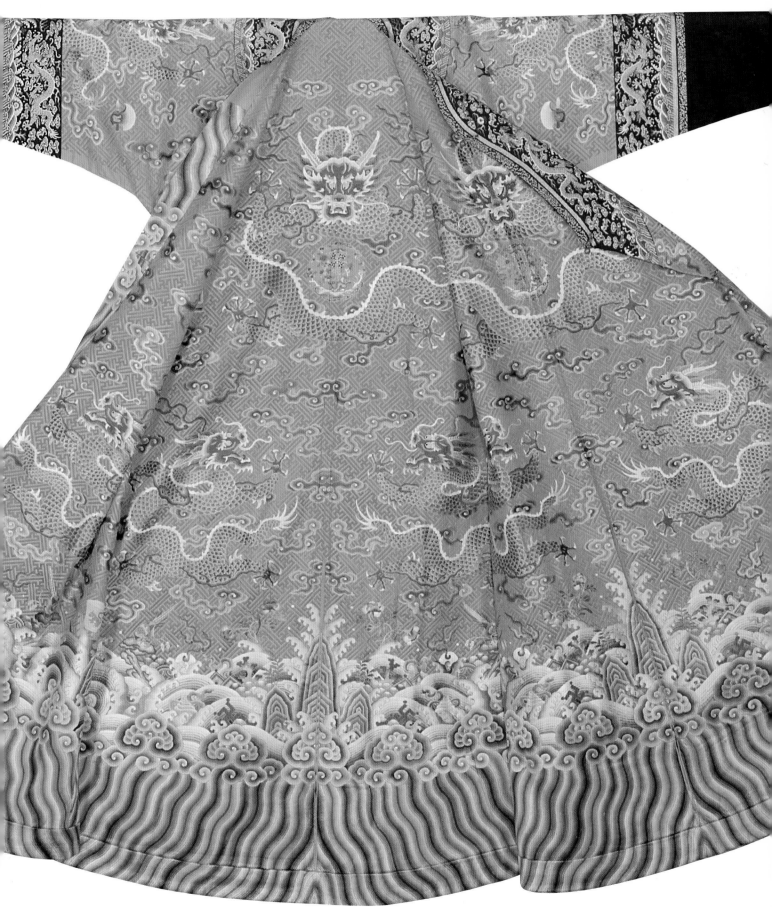

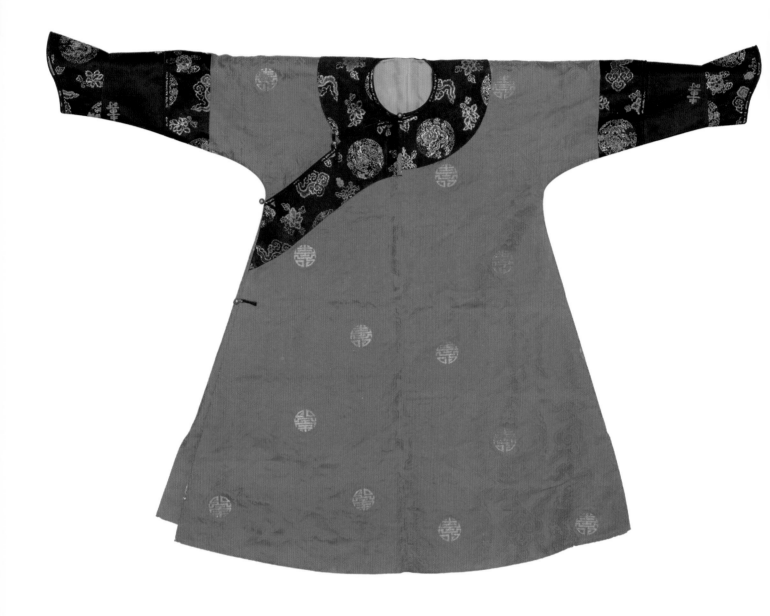

27. Princess's padded festive robe
Golden yellow satin with woven pattern
Kangxi reign period (1662–1722)
Gu41684

A child princess would have worn this small robe. It is made from golden yellow silk with a self-pattern of clouds and dragons and a design of gold 'long life' characters. It is marked out as a festive robe by the style of the trimmings, which are in a contrasting colour and applied to the cuff ends, the sleeves, the neck and the collarbone closure.

28. EMPRESS'S WINTER FESTIVE HAT

Sable, peacock feather, coral beads, red silk knot
Qing dynasty (1644–1911)
Gu59712

THE CROWN OF THIS HAT is decorated with peacock feather filaments which would have appeared iridescent as they caught the light. The feathers are set into a metal framework in the shape of entwined clouds and 'long life' characters, and there are flying bats, also in the same technique, around the central red knot. Tiny coral beads, again set into metal, form more 'long life' characters. According to Qing regulations, this hat should be topped by a pearl, not a red silk knot. It was probably an error of the palace eunuchs in the late years of the dynasty.

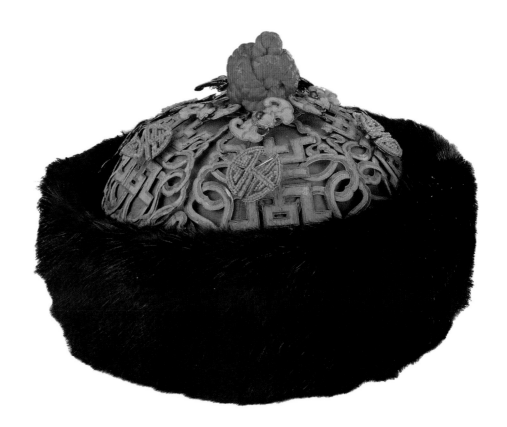

29. EMPRESS'S FESTIVE HEADDRESS (*DIANZI*)

Rattan strips, silk netting, peacock feather, pearls, gold, semi-precious stones
Guangxu reign period (1875–1908)
Gu59708

THIS HEADDRESS WAS PART of the formal attire of Empress Jing Xiaoding, consort of the Guangxu emperor. The style is more an addition to the female coiffure rather than a crown or hat. It is made from a variety of materials and features stylized phoenixes. The strings of pearls, terminating in coloured semi-precious stones, and other elements standing out from the headdress on flexible metal stalks would have vibrated or swung to and fro every time the wearer moved.

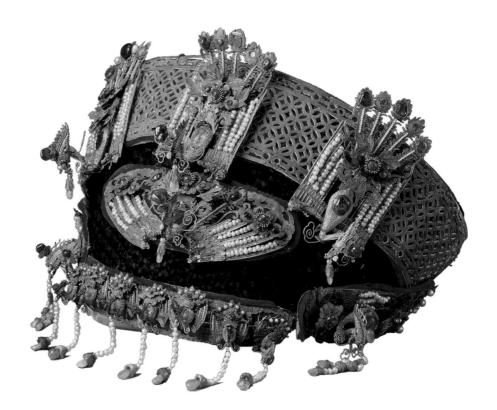

EMPEROR'S TRAVELLING DRESS

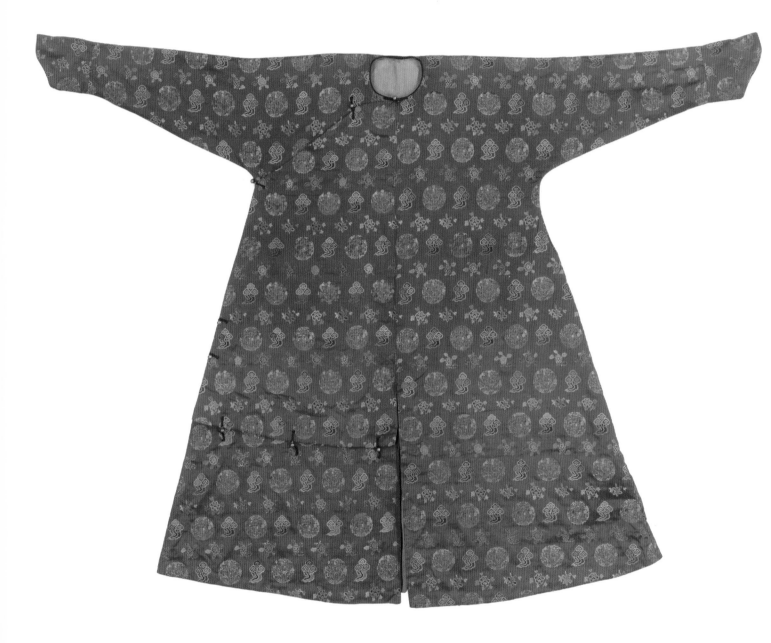

**30. EMPEROR'S PADDED
TRAVELLING ROBE**
Red satin with woven pattern
Kangxi reign period (1662–1722)
Gu41745

TRAVELLING ROBES were usually
made of plain or subtly
patterned fabric. This robe in
bright red silk with a colourful
pattern is a rare exception.

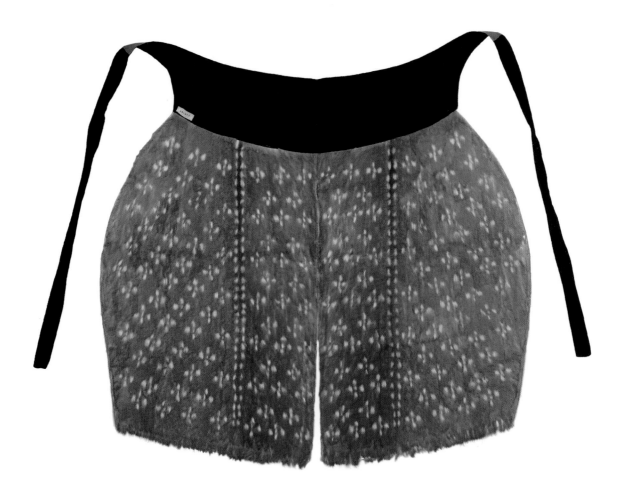

31. EMPEROR'S RIDING APRON
Deer skin, dark blue cotton waistband
Yongzheng reign period (1723–35)
Gu50951

THIS SHORT APRON-LIKE GARMENT with a slit front was designed to provide warmth and protection for prolonged horseback riding. In Europe and America, these aprons are called 'chaps'. They make a sturdy covering for the legs and are fixed to the body by ties on a waistband and by straps, not visible in the illustration, that go around the wearer's thighs.

EMPEROR'S REGULAR DRESS

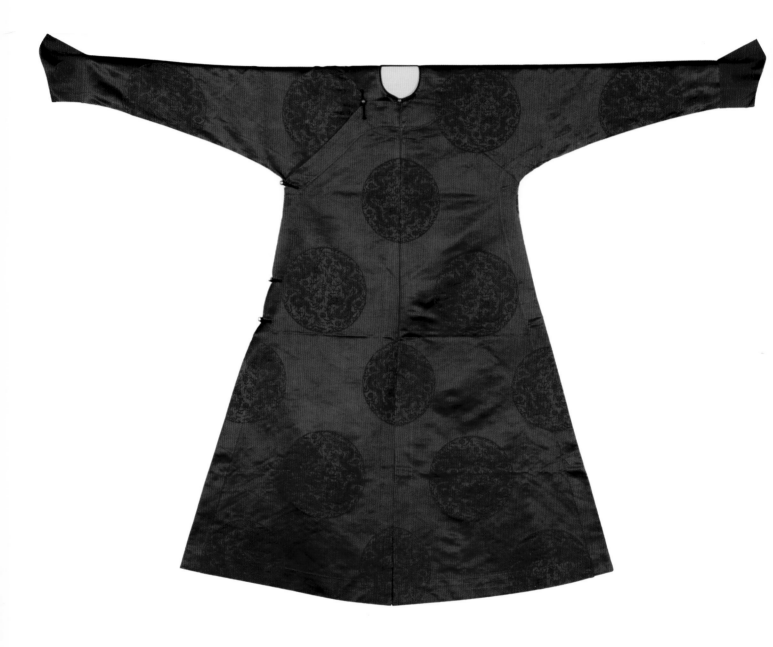

32. EMPEROR'S REGULAR ROBE
Burgundy-colour silk with woven pattern
Qianlong reign period (1736–95)
Gu42548

THIS ROBE, WORN BY the emperor on sombre occasions, such as the anniversaries of the deaths of past emperors and empresses, was called a 'regular' robe. They were usually made of fabrics of sober colours and embroidery was seldom used. A subtle design, however, was often woven across the surface of the silk, as in this case.

33. EMPEROR'S REGULAR ROBE
Grass green silk with woven pattern
Guangxu reign period (1875–1908)
Gu45831

AS WITH OTHER REGULAR ROBES, the monochrome colouring is enhanced by an understated design woven into the silk. Apart from the narrow black trim around the neck and the black silk of the button shafts and loops, there are no contrasting edgings on these types of robes.

34. EMPEROR'S REGULAR SURCOAT
Dark blue silk with woven pattern
Qianlong reign period (1736–95)
Gu47019

THE EMPEROR WOULD HAVE worn this surcoat on top of the regular robe, extending the layered effect so familiar from the more formal court and festive robes to these types of garments.

35. EMPEROR'S REGULAR JACKET
Bright yellow silk with woven pattern, sable
Daoguang reign period (1821–50)
Gu45102

THIS JACKET IS REVERSIBLE, the other side
being made of sable.

EMPRESS'S REGULAR DRESS

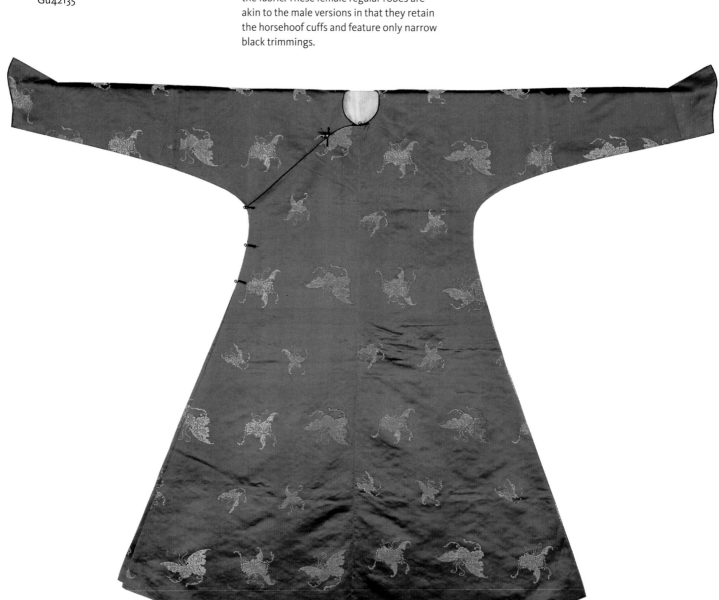

36. EMPRESS'S PADDED REGULAR ROBE

Bronze-colour satin with woven pattern
Qianlong reign period (1736–95)
Gu42135

THE BUTTERFLIES ON THIS ROBE, in alternating rows of large and small insects, are beautifully woven in gold thread, adding a subtle radiance to the restrained colour of the fabric. These female regular robes are akin to the male versions in that they retain the horsehoof cuffs and feature only narrow black trimmings.

37. EMPRESS'S REGULAR ROBE

Silver satin with woven pattern
Daoguang reign period (1821–50)
Gu45839

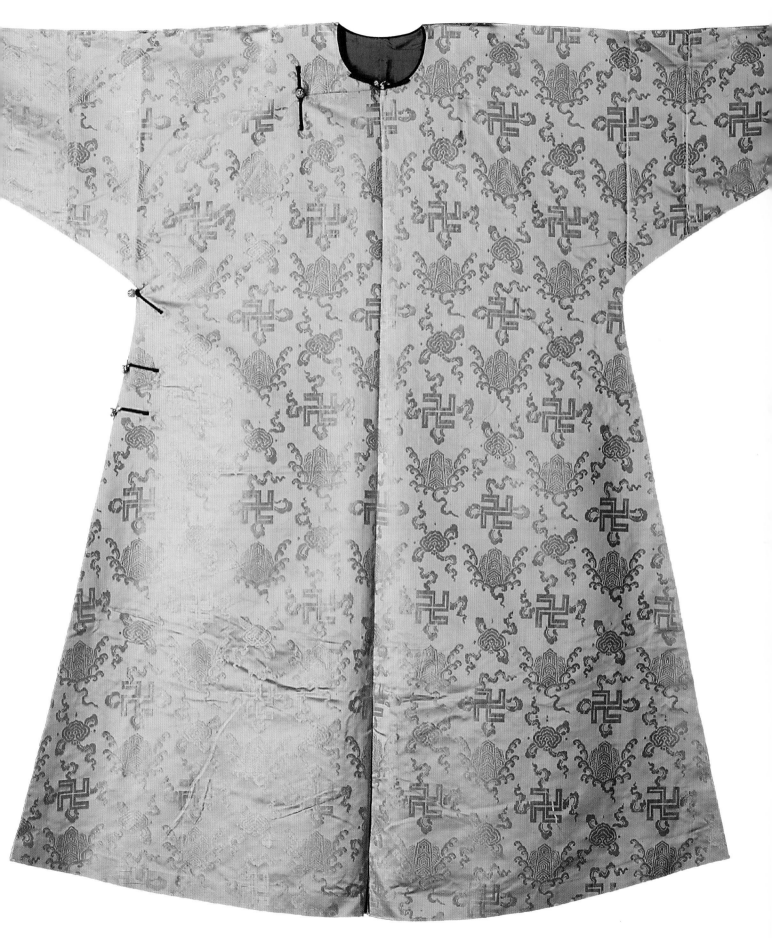

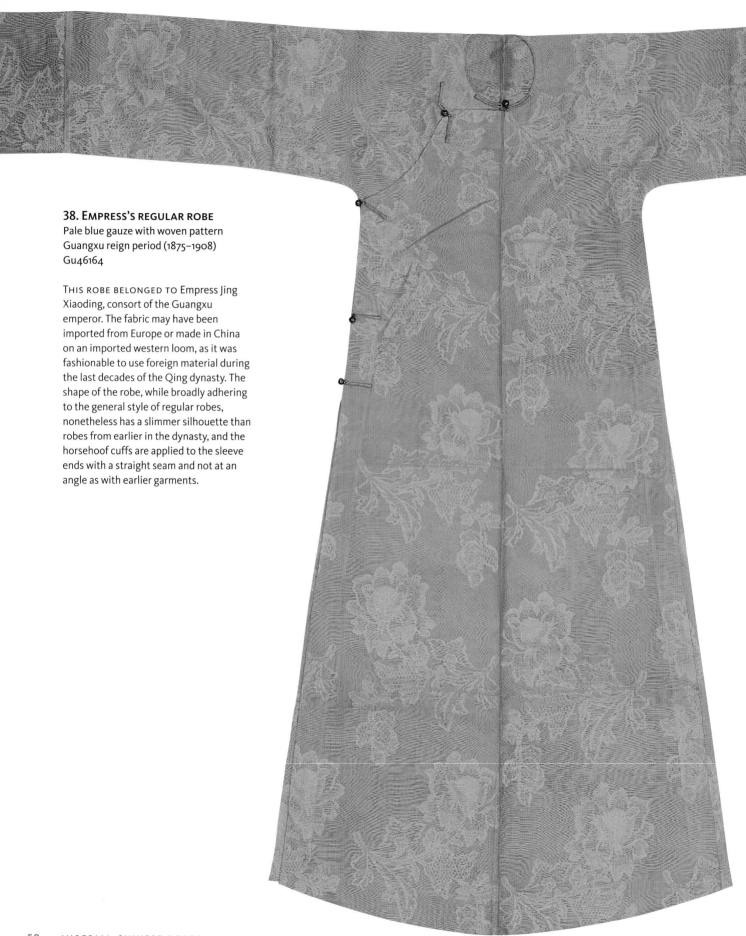

38. EMPRESS'S REGULAR ROBE
Pale blue gauze with woven pattern
Guangxu reign period (1875–1908)
Gu46164

THIS ROBE BELONGED TO Empress Jing Xiaoding, consort of the Guangxu emperor. The fabric may have been imported from Europe or made in China on an imported western loom, as it was fashionable to use foreign material during the last decades of the Qing dynasty. The shape of the robe, while broadly adhering to the general style of regular robes, nonetheless has a slimmer silhouette than robes from earlier in the dynasty, and the horsehoof cuffs are applied to the sleeve ends with a straight seam and not at an angle as with earlier garments.

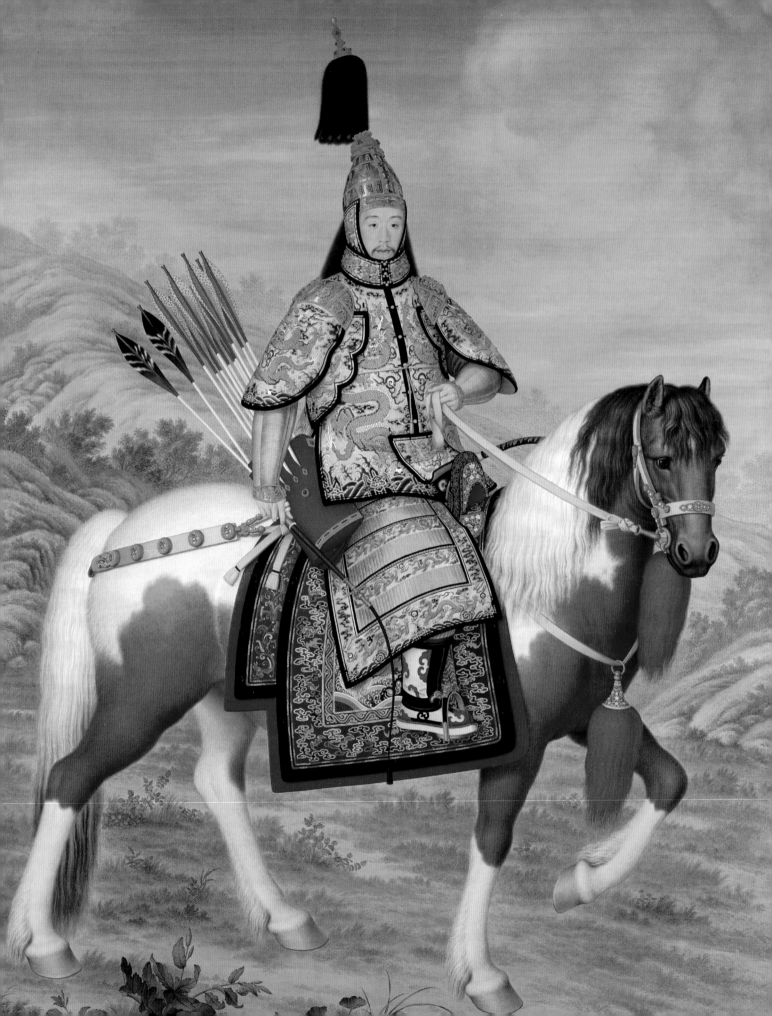

3. CEREMONIAL ARMOUR OF THE QING EMPERORS

Zhang Qiong

OF ALL CHINESE RULERS the Qing emperors placed the greatest importance on military strength, probably because they were deeply conscious that they had won the country by martial prowess. In 1650 the first Qing emperor Shunzhi (r.1644–61) declared: 'Our dynasty was built on military might. Now the country is unified and peace prevails. But we should always be vigilant. We should maintain our supremacy in riding and archery. Henceforth an inspection of the militia should be made once every three years.'

This 'once every three years' rule was not strictly adhered to. The Kangxi emperor ascended the throne in 1662 but held his first grand military inspection in 1673. Between 1690 and 1695, however, he conducted an inspection every year, the events generally interpreted as political manoeuvres more than anything else. Historians suggest that the emperor's intention was to fill his enemies with awe by showing off his armies and weapons rather than engaging in battle. To win without going to war is the best scenario any ruler could wish for.

According to Palace records, in the winter of 1685 several chieftains of the Khalkha Mongols and Oirat Mongols were in Beijing and were invited to attend the grand inspection. The spectacle apparently made them tremble with fear. They prostrated themselves and acknowledged that 'the horses are robust and the men strong, the weapons sharp and the armours solid, the canons so powerful as never seen or heard of'. They went home convinced that the Qing dynasty was invincible.

In 1758 the Qianlong emperor (r.1736–95) followed the example set by his grandfather. Kazakh and Burut envoys visiting Beijing were given the opportunity to watch a military parade, one of the manoeuvres being 2,000 cavalrymen charging at each other. In the same year troops were sent to subdue the rebellious Khoja brothers who occupied the regions south of the Tianshan mountains in east Turkestan. The emperor commemorated the event with a painting of himself in full ceremonial armour (fig. 4).

The Palace Museum collection contains suits of armour labelled as belonging to the founding fathers of what was to become the Qing dynasty, Nurgaci (r. 1616–26) and Hong Taiji (r. 1627–43). Nurgaci's suit is fairly simple, consisting of a long tunic, two iron-plated sleeves and two armpit guards (fig. 5). According to an archival record, a total of 220 iron strips were embedded between the two layers of textile of the tunic.

Hong Taiji's suit consists of a jacket and apron, two iron-plated sleeves and two armpit guards (fig. 6). The most obvious difference between this suit and the previous one is the replacement of the long tunic by a jacket and apron.

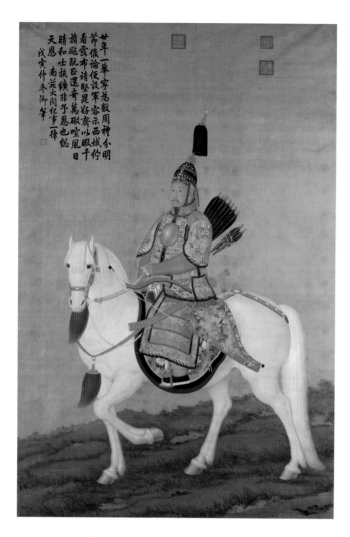

天恩戎寅仲冬御筆
戊寅仲冬南苑大閱紀事一律
和士挾續非予恩也緫
精飊瓦還奇萬礮喧風瞬日千
看雲佈諸旗好齊山暇
節候論便設軍容示西拔
廿年一舉寧苟數周禋小明
日俟曉便行佇

Fig 4: Painting of Qianlong emperor wearing ceremonial armour, 1758
Palace Museum Gu006488

The two trapezoidal flaps, known as 'front protector' and 'left protector', were new inventions, acting as cushions against friction caused by the wearer's rapid movements on horseback.

This two-piece style underwent further improvements. By 1650 the Shunzhi emperor's suit of armour has abandoned the two long iron-plated sleeves. Instead they have become half sleeves for the lower arms only, made of metal hoops. The upper arms are protected by the extended shoulder guards. At the same time the suit has become more ornate, as witnessed by the highly decorative shoulder guards, breast plate and sleeve cuffs. Coral beads and semi-precious stones have also been added to the shoulder guards (fig. 7).

The helmets belonging to Nurgaci and Hong Taiji are very similar. Both are made of iron, embellished with gilt

bronze rims and ridges. A satin skullcap would have been worn beneath the metal headgear. The nape guard and ear guards are made of satin matching the tunic or jacket, but are padded with iron strips. Shunzhi's helmet is, again, much more magnificent. It has a finial made of gold filigree, set with eighteen pearls and topped by a large pearl. Thirty dyed sables hang from the finial.

In 1756 the Qianlong emperor formally laid down the rules on how the emperor's ceremonial armour should be styled, and the materials to be used, as follows:

THE HELMET: made of leather, then lacquered; with a ridge in the front and at the back, carved with dragon or snake pattern, set with pearls, cat's eye stone, ruby, sapphire and topaz; to the left and right of the ridges should be three rows of Buddhist texts, the first row with eight Sanskrit characters, the second row eighteen characters interspersed with jewellery pattern, and the third row twenty four characters.

THE ARMOUR: made of bright yellow satin, moon white lining, filled with cotton in between, dark borders, gold studs affixed across the surface; consists of a jacket with front protector flap and left protector flap, an apron, two shoulder guards, two armpit guards and two sleeves; the various members of the suit to be embroidered with either rising dragons or full-face dragons; a breast plate and a back plate to be worn on top.

Plate 39 accords with these descriptions very well, suggesting that the suit was made a few years after 1756. It is interesting to note that iron strips were no longer used to line the armour; the jacket and apron are now padded with cotton. The sleeves have been given rings of stitches to simulate metal hoops, and the apron, although it retains the rows of gold studs, lacks the iron strips as seen on Shunzhi's apron. All these features clearly signal the increasingly ceremonial, rather than practical, function of the outfit.

Qianlong commissioned two portraits of himself wearing ceremonial armour and both are now preserved in the Palace Museum. The first dates from 1739, when he conducted his first grand military inspection since ascending the throne (page 60). The second is from 1758. The emperor wrote a poem on this painting in his own handwriting (fig. 4). One portrait shows the emperor facing right and the other facing left. From the 1739 portrait we can see a

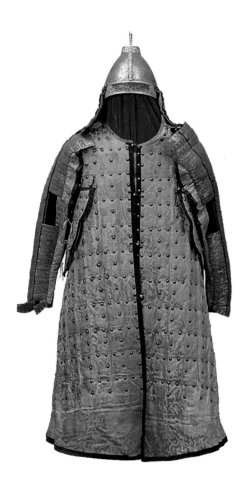

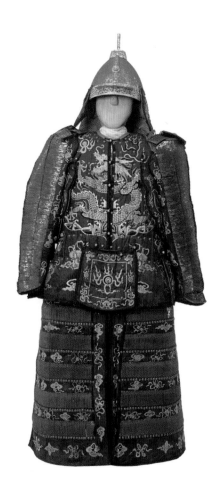

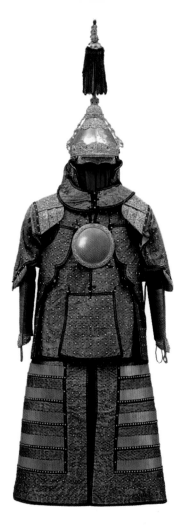

Fig. 5: Suit of armour of Nurgaci
Palace Museum Gu171804

Fig. 6: Suit of armour of Hong Taiji
Palace Museum Gu171805

Fig. 7: Suit of armour of Shunzhi emperor
Palace Museum Gu171803

quiver made of brown leather with two types of arrows in it; the 1758 portrait shows how Qianlong wore his bow and sword. The sword and scabbard were worn under the jacket in a rather singular way, with the scabbard tip pointing ahead. The bow, half-hidden by the highly ornate bow case, was worn under the left protector flap.

In the early years of the dynasty the protector flaps were made of deerskin, a hardwearing material, indicating that they indeed served some practical function. But the position of the left flap in relation to the bow was unknown. If the bow was worn above the left flap, the purpose of the flap would have been to protect the rider's thighs from

being chafed by the bow. If the bow was worn under the flap, as shown in the portrait, one can only surmise that the flap's function was to prevent the bow being caught in the metal hoops on the rider's left sleeve.

Qianlong's suit of armour was purely ceremonial and not for combat. The protector flaps were made of satin, their 'protective' quality existing in name only. Consequently, whether the bow was worn above or under the left flap became immaterial, though by this time the aesthetics of a correct pose, divorced from any practical soldierly considerations, may have had some bearing on how the emperor was pictured by the artist.

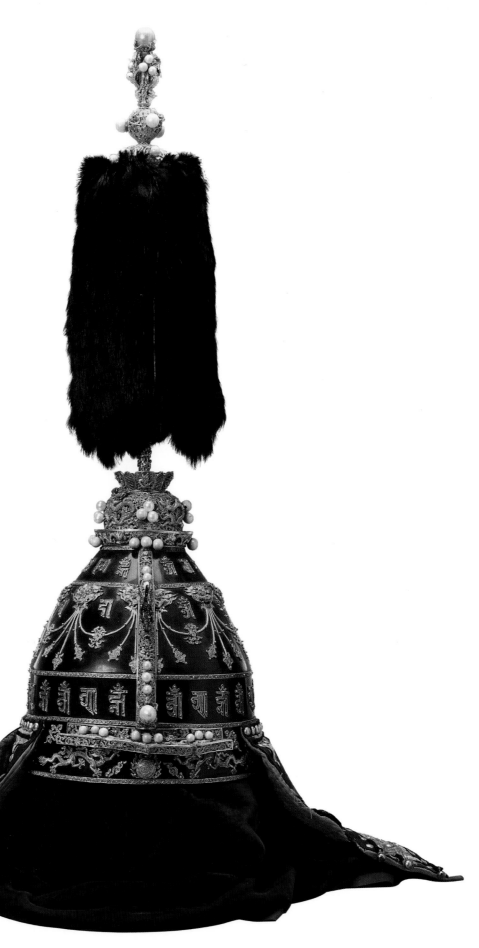

39. EMPEROR'S CEREMONIAL ARMOUR

Bright yellow satin with embroidered
pattern, copper studs, metal plate
Qianlong reign period (1736–95)
Gu171798

THE EMPEROR WOULD HAVE worn this
set of armour on state military occasions.
Although it approximates to real armour,
with all the segments carefully reproduced,
it is a purely ceremonial outfit, one that
would not have afforded much protection
in battle. The sleeves are banded in closely
sewn strips of gold thread to resemble
shining metal. The embroidery designs
themselves and the way they are arranged
on the silk, as well as the colour, mirror
some of the other official attire of the
emperor. Each section is padded and lined
with blue and fitted together by toggles
and loops.

39A. EMPEROR'S HELMET

Lacquered leather, gold, pearls, sable
Qianlong reign period (1736–95)
Gu171125 and Gu171813/9

THE IMPRESSIVE HELMET, with its high
finial and sable plume, is decorated with
Sanskrit magic formulae from Tibetan
Buddhism, called *dharani*. These tell us
that the emperor saw himself as the
supreme ruler of a multi-ethnic empire.

4. WOMEN'S INFORMAL WEAR AT THE IMPERIAL COURT IN THE LATE QING DYNASTY

Yin Anni

THE INFORMAL WEAR for Qing dynasty emperors and members of his family was not regulated; when the emperor had no official duties to discharge he would wear whatever he chose. Informal robes for men were plain by comparison with the official and festive garb described elsewhere, though their shape and cut were similar. However, the sleeve ends were not shaped but cut straight.

In the mid-nineteenth century, the riding jacket (*magua*) was introduced into the informal wardrobe of both men and women (plates 47, 48, 49 and 57). Despite its appellation, the riding jacket was worn as much by people on foot as those on horseback. It is a short overgarment, edged in a contrasting border and usually with a high, close-fitting collar. A sleeveless version – the *jinshen* (literally 'close-fitting garment') – evolved from this riding jacket. This new sleeveless garment was popular with both men and women, and if the material was of a neutral pattern and colour it was not always possible to tell the gender of the wearer (plates 51, 52 and 56).

The court ladies themselves helped to popularize, and perhaps even introduce, some changes to women's fashion. The first was the modification of the lady's informal robe. The second was the invention of an outer gown (*changyi*). These two changes brightened up the ladies' imperial living quarters within the Forbidden City. When dynastic rule ended and China became a republic in 1912, it was the informal robe that became the prototype of the dress perceived as particularly Chinese, the cheongsam (*qipao*), which was worn throughout the 1930s and 1940s by both Han and Manchu women alike.

THE EMPRESS'S INFORMAL ROBE

Before the nineteenth century, the empress's informal robe was very similar to that of her husband. A floral or butterfly pattern on a robe (plate 40) can be an indicator that the robe was for a woman. An empress had far more opportunity to wear this unregulated style of robe than the emperor, however, for she was excluded from many of the ceremonies of state; she would spend much of her time with the palace womenfolk on family matters.

The Daoguang emperor's reign period (1821–50) saw the widening of the sleeves, which hitherto had always remained narrow. The emperor himself was none too pleased, as he interpreted it as an abandonment of Manchu tradition. He apparently tried to ban it, but to no avail. Next, layered sleeves appeared (plate 41), a feature that required an elaborate production process. The ends of the sleeves were folded and edged in several bands of silk, each of a different width. Some of these applied edgings were embroidered while others were lengths of woven silk cut on the bias. Still others were ribbons woven especially for this purpose on a narrow loom. Each cuff layer, their apertures progressively narrowing towards the wrist, had to relate to its neighbour, as well as to the main

body of the garment, either in pattern or colour scheme, and together they enhanced the total effect of the robe.

The trend for wide layered sleeves started outside the court, the palace ladies merely trend-followers rather than setters. But they had the best weaving mills and an army of dressmakers at their disposal, so the informal robe of an empress or imperial concubine was more elaborate than that of a commoner. The green gauze robe (plate 41), for example, has sleeves of three layers, made up of no less than nine bands and ribbons. The neck opening, the side and the hem are adorned with matching borders. These in turn echo the design of the main material, which is one of floral sprays embroidered in pink and 'longevity' characters embroidered in gold. Careful planning and co-ordination were needed in the production of this robe.

In the last two decades of the nineteenth century and the first of the twentieth century, the court ladies gained knowledge of European fashion. The presence of European women in Beijing and the spread of photography must have made some impact on Chinese fashion within the Forbidden City. At this time, the informal robe, sometimes with a stand-up collar, took on a much slimmer silhouette, perhaps as a result of these outside influences (plate 42).

The Informal Outer Gown (CHANGYI)

While the informal robes just described could be worn alone or with a riding jacket, court ladies had one additional choice: they could wear an informal outer gown, known as a *changyi*, in lieu of the riding jacket.

Changyi literally means 'wide dress', due to the wide cut of the body. At first glance the informal outer gown looks very similar to other robes. A distinct feature of this outer gown, however, is the long slit, from underarm to hem, on each side of the garment. To accentuate the slits, wide borders are sewn along them, terminating in a pattern known as '*ruyi* cloud head' (plates 44 and 45). These outer gowns are usually extremely colourful and very feminine. It was this style of robe that encouraged court ladies to vie with one another to come up with the most eye-catching design.

Embroidery features abundantly on these gowns, with satin damask and gauze being the most popular fabrics.

Coloured silk yarn, gold- and silver-wrapped threads and tiny seed pearls were employed to create a sumptuous effect. Seasoned embroiderers knew how to best exploit the metallic sheen of the gold and silver threads and the milky gleam of the pearls. Against the smooth surface of the silk fabric the patterns acquired a three-dimensional quality. Traditional and innovative stitching techniques combined to make the garment an exquisite item of pure luxury, setting it above the ordinary products destined for commoners.

Production Processes

Although these more informal robes were not bound by regulations, it was understood that the bright yellow colour, whether for the main material or for the lining, was still exclusive to the empress dowager and empress. In addition, the dragon motif was seldom used.

A document in the palace archive, dating to 1873, reveals that orders for informal robes and outer gowns were sent to the Suzhou Textile Manufactory together with paper patterns, in very much the same manner as orders for more formal dress (see Chapter 5). The document also mentions the sum of 75,818 taels of silver being paid for ninety-eight lengths of dress material. That equals 773 taels per length, an exceedingly large sum for a clothing item (773 taels would be approximately £257 at the time).

Of the ninety-eight lengths, only three pieces were for dragon robes, the rest being thirty-six lengths for informal outer gowns and fifty-nine lengths for other informal robes. The three dragon robes were of tapestry weave, a labour-intensive, hence expensive, material. The informal outer gowns and robes, with their attendant matching borders and ribbons, would have required no less time and skill to make. In the late nineteenth century, the Imperial Household Department was well known for its extravagance, with many of its officers illegally profiting from all kinds of imperial purchase orders.

In 1873 the Tongzhi emperor (r. 1862–74) was seventeen years old, so the fifty-nine female informal dresses were most likely for the consumption of his mother, the Empress Dowager Cixi (1835–1908). Whether or not Cixi knew about the staggering cost of the dresses is difficult to ascertain.

INFLUENCE FROM HAN CHINESE AND EUROPEAN FASHION

The early Qing emperors were worried about the erosion of the Manchu tradition; their worries turned out to be well founded. The informal dress, as it was not regulated, was open to all kinds of influences from Han Chinese styles and, from 1860 onwards, European styles too. Two new features appeared on the informal attire of men and women, provoking some comments from contemporary writers.

The first was the multiple border, which has already been touched on in connection with the layered sleeves. Decorative trims on clothes were originally a common feature among Han Chinese women, and in the mid-nineteenth century these trimmings became increasingly elaborate. The trend found its way to the court and quickly won the favour of the court ladies. The number of borders and edgings on an informal robe or jacket tripled or quadrupled, to the extent that the vogue was called 'eighteen trimmings'. With some lightweight summer dresses the decorative borders were heavier than the primary fabric of the dress. Multiple borders remained a prominent feature of women's fashion until the end of the dynasty, and can be seen on informal robes with or without the layered sleeves.

The second was the proliferation of buttons of numerous types. The traditional button on a Manchu robe is spherical, formed out of a knot of satin or gilt bronze. Definitely of 'foreign' origin was the die-cast, flat, coin-shaped buttons which were given a Chinese guise with auspicious messages such as 'longevity', 'blessings' and 'prosperity' (plates 48, 56 and 57). Innovative use of materials included stringing together tiny seed pearls of different tones to form Chinese characters such as *daji* ('great auspiciousness'). Also unique to the late Qing were fastenings made of white jade and jadeite, which came in a variety of shapes – lotus leaf, goldfish, bat and several others. These buttons and fastenings can be seen on informal robes and riding jackets for men and women alike, and are a distinctive clothing trend of the closing decades of the dynasty.

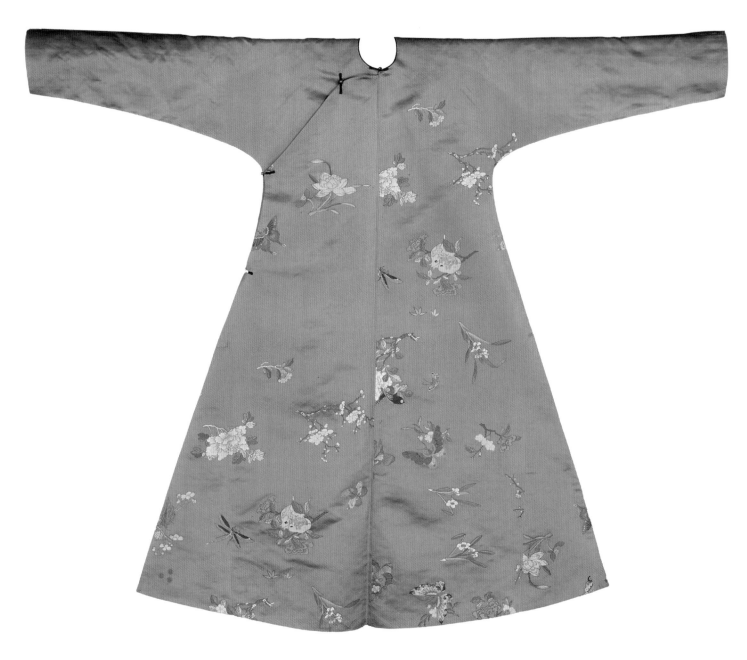

40. EMPRESS'S INFORMAL ROBE
Pale blue satin with woven pattern
Qianlong reign period (1736–95)
Gu42137

IN THE NINETEENTH CENTURY court, ladies created their own fashions. In the early years of the Qing dynasty, however, the informal robes for men and women were similar, though the women's styles were perhaps slightly more colourful, with several shades appearing on one garment as here. This pale blue robe has flowers and butterflies of various colours woven into it, though the empty section of silk on the right overlap is puzzling; it may be that the garment has been wrongly tailored because the motifs are sliced off across the central seam.

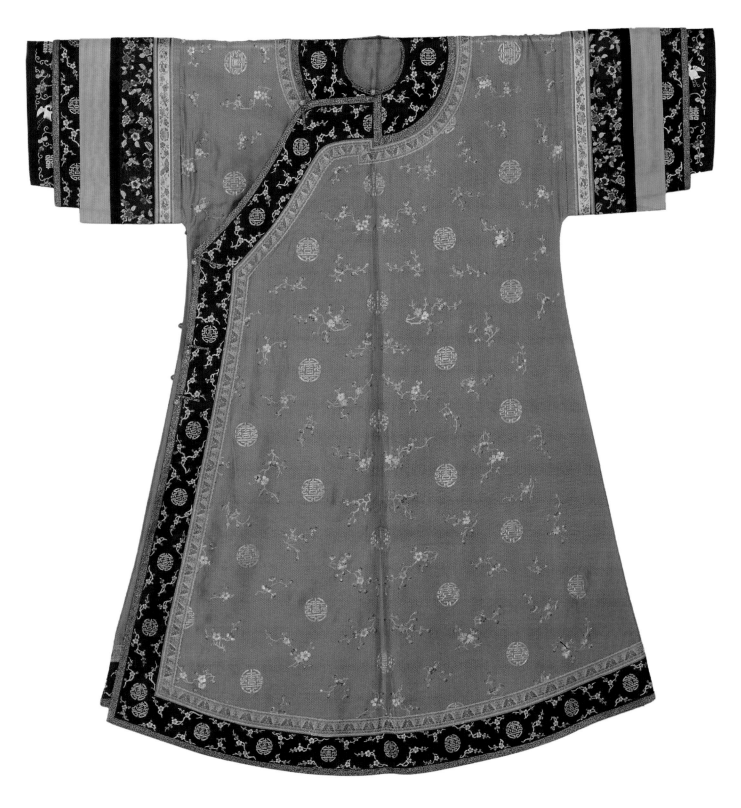

41. WOMAN'S INFORMAL ROBE
Green gauze with embroidered pattern
Tongzhi reign period (1862–74)
Gu44559

THIS LOOSE-FITTING ROBE has
layered cuffs and multiple borders.
Such elaborate tailoring is a sign of
imperial production.

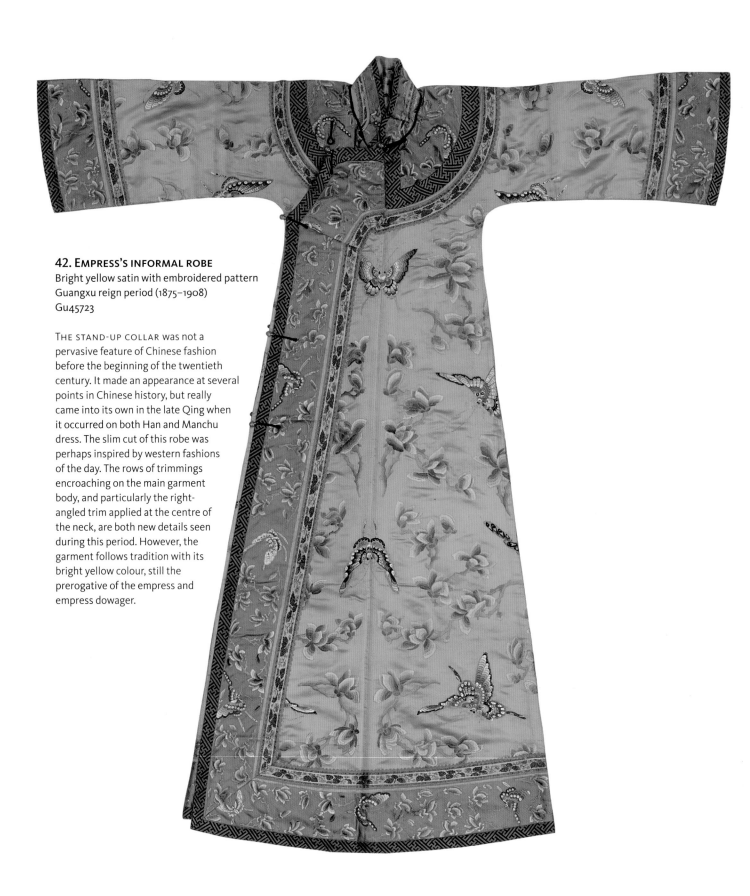

42. Empress's informal robe
Bright yellow satin with embroidered pattern
Guangxu reign period (1875–1908)
Gu45723

THE STAND-UP COLLAR was not a pervasive feature of Chinese fashion before the beginning of the twentieth century. It made an appearance at several points in Chinese history, but really came into its own in the late Qing when it occurred on both Han and Manchu dress. The slim cut of this robe was perhaps inspired by western fashions of the day. The rows of trimmings encroaching on the main garment body, and particularly the right-angled trim applied at the centre of the neck, are both new details seen during this period. However, the garment follows tradition with its bright yellow colour, still the prerogative of the empress and empress dowager.

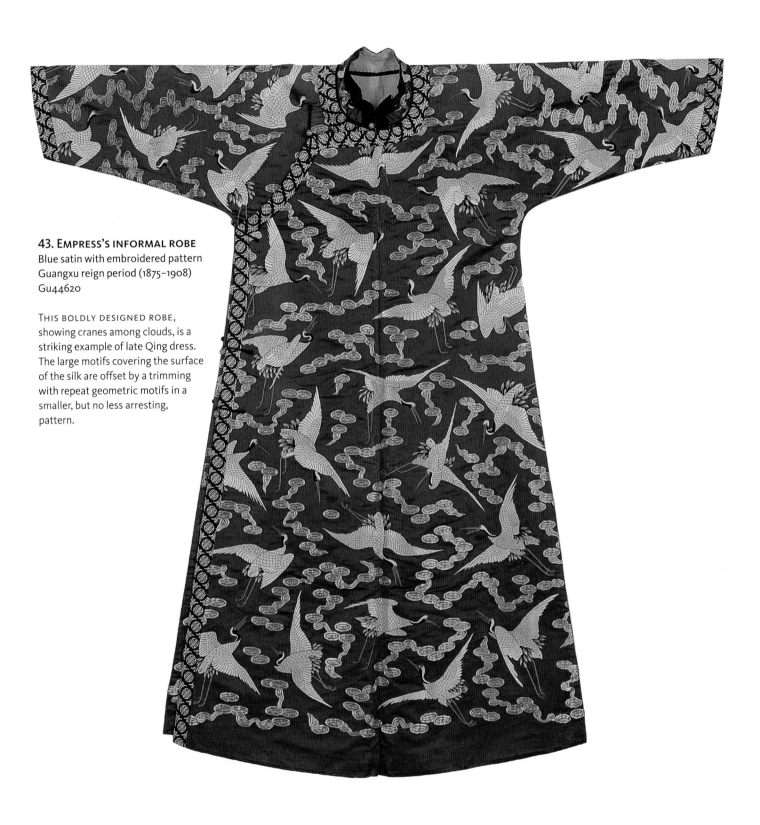

43. EMPRESS'S INFORMAL ROBE
Blue satin with embroidered pattern
Guangxu reign period (1875–1908)
Gu44620

THIS BOLDLY DESIGNED ROBE,
showing cranes among clouds, is a
striking example of late Qing dress.
The large motifs covering the surface
of the silk are offset by a trimming
with repeat geometric motifs in a
smaller, but no less arresting,
pattern.

44. EMPRESS'S INFORMAL OUTER GOWN (*CHANGYI*)

Bright yellow silk with embroidered pattern
Guangxu reign period (1875–1908)
Gu45277

THE OUTER GOWN was an alternative to the riding jacket usually worn on top of an informal robe. It has a wide cut, and is distinguished from the informal robe by the two slits on the sides that rise up to the armpit. The shaped trimming applied at the top of the slits is also a feature of this kind of garment. Some gowns have contrasting trims, while others, as here, have applied edgings that mirror the motifs on the main body of the robe, in this case bunches of grapes. Grapes, on a smaller scale, decorate the widest trim, which is itself framed either side by a narrower woven border.

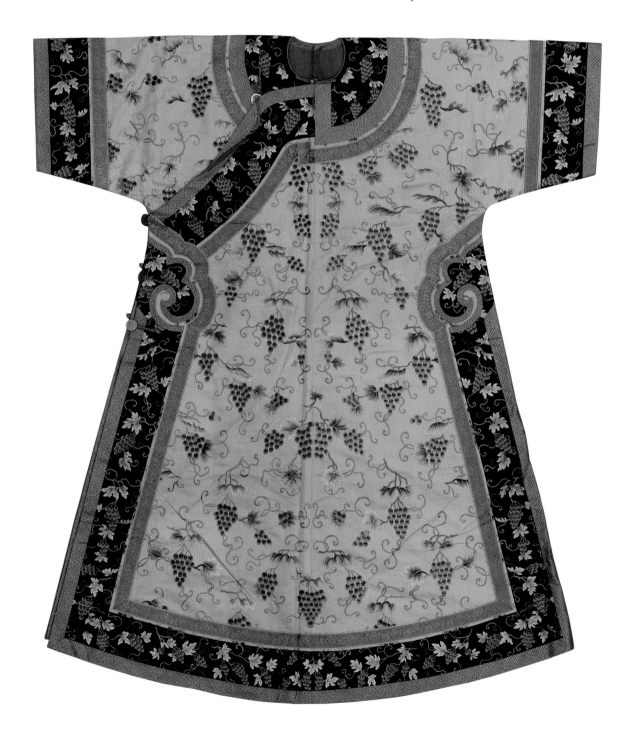

45. WOMAN'S INFORMAL OUTER GOWN
Red satin with embroidered pattern
Daoguang reign period (1821–50)
Gu43866

THIS IS ANOTHER EXAMPLE of the informal outer gown. Court ladies found much delight in outshining their peers with the most eye-catching design.

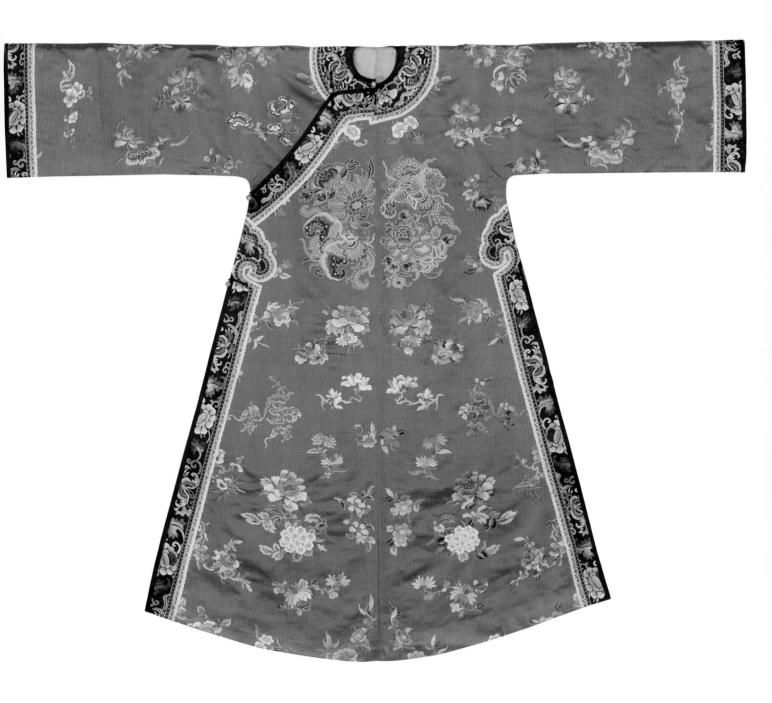

46. EMPRESS'S INFORMAL JACKET
Bright yellow silk, sable, ermine
Jiaqing reign period (1796–1820)
Gu44967

THIS DOUBLE-SIDED JACKET would have been worn during a wedding. White ermine fur is set among the brown sable to form 'double happiness' characters.

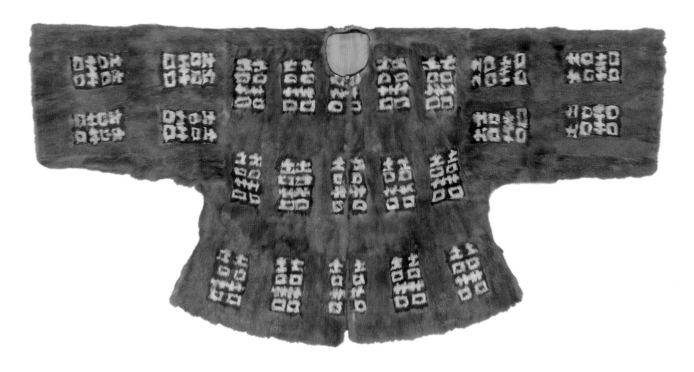

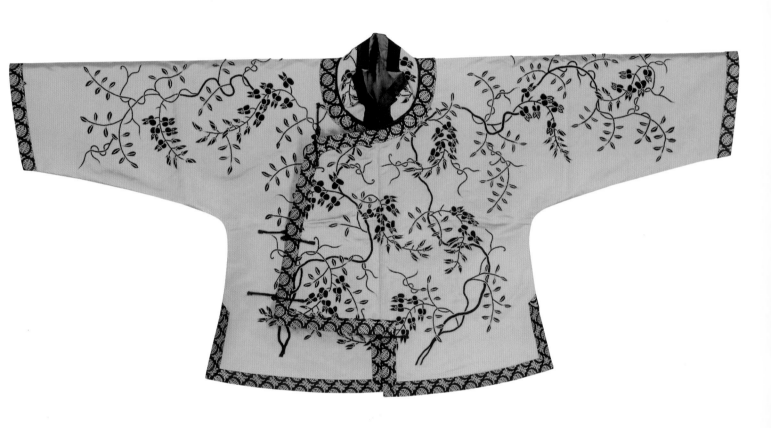

47. WOMAN'S RIDING JACKET (*MAGUA*)
Pale blue satin with embroidered pattern
Guangxu reign period (1875–1908)
Gu49300

THE CUT OF THIS JACKET is based on the riding jacket worn by the Manchu people before they became rulers of China. The L-shaped overlapping closure is called the '*pipa* style', because it resembles the shape of a stringed musical instrument of that name. The wisteria pattern, embroidered in dark blue, was very popular at this time.

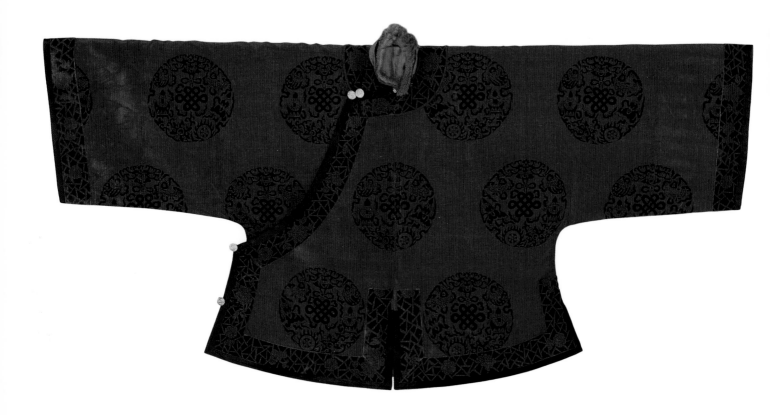

48. Woman's padded riding jacket (*magua*)
Blue patterned velvet, squirrel fur
Late Qing dynasty (1862–1908)
Gu48501

This jacket closes at the side and has a slit in the lower front, perhaps to accommodate the gown worn beneath it. The roundels enclose the Eight Buddhist Symbols: the canopy, the fish, the parasol (or umbrella), the wheel, the lotus, the vase, the conch shell, and the endless knot in the centre. This decorative scheme was a favourite combination for dress of all kinds and does not in any way signify that the garment itself had any religious purpose.

49. Imperial concubine's riding jacket (*magua*)
Green satin with woven pattern, sable
Guangxu reign period (1875–1908)
Gu49938

This jacket has three different borders, one made of fur, one of woven satin, and one of lace ribbon. The 'longevity' characters on the fur border are formed with sables of a paler colour than the ground. Lace making, not a technique traditionally associated with China, appears to have been introduced into the country by Catholic nuns. It was much in demand for trimmings and, although the border on this green jacket was probably hand-made, very soon after this time industrial lace making began to develop rapidly.

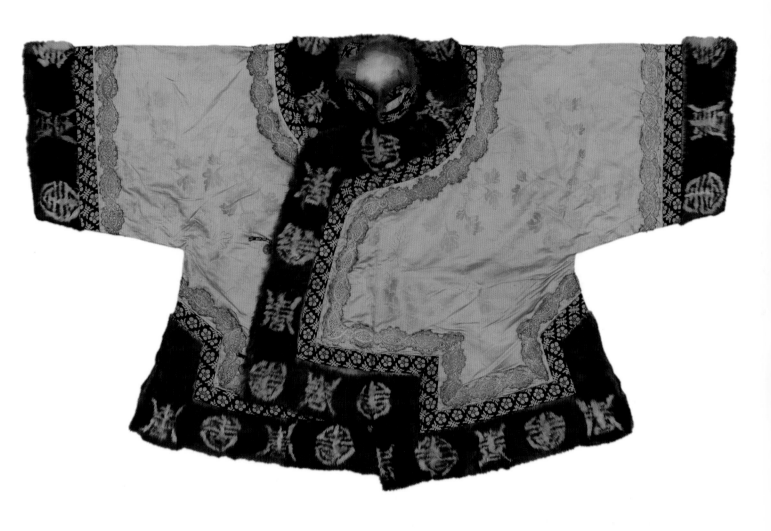

50. Empress's informal sleeveless coat

Dark blue satin with
embroidered pattern
Qianlong reign period (1736–95)
Gu43472

THIS EARLY STYLE OF LONG sleeveless coat, like its later but shorter counterpart, would have been worn on top of an informal robe. As on all overgarments, the armholes are generously cut to make room for the robe worn beneath. The trimming, in the form of curlicues, just under the armholes and at the centre front, anticipates the later *changyi* fashion, as seen in plate 44. The 'pinked' narrow ribbon trim applied to the inside of the wider border and the white corded outline of the curlicues add visual interest to the plain blue satin ground. The large-scale crane design, skilfully embroidered to match across the front opening, goes over the trimming. It is not clear how the ribbons attached at either side would have been tied, if at all.

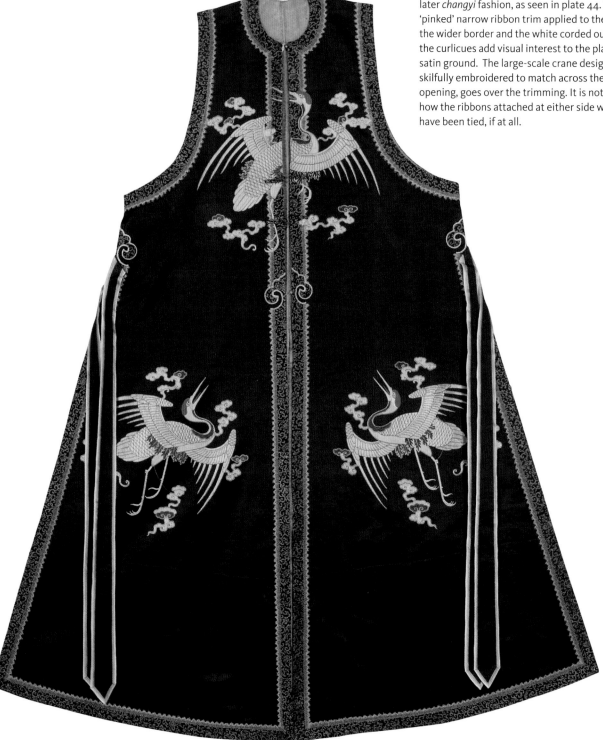

51. Woman's informal sleeveless waistcoat (*Jinshen*)
Silk with tapestry-woven pattern
Late Qing dynasty (1862–1908)
Gu47994

ANOTHER STYLE OF OVERGARMENT is exemplified by this waistcoat. Wide armholes and a stand-up collar are features it shares with other clothing types, but instead of a centre or side opening, it has a totally removable front, and a back section that folds over at shoulder level to fasten horizontally with round jade buttons across the top chest. Three more buttons down each side secure the lower part. This garment shape, because it is not divided or cut by openings, lends itself to a pictorial type of decoration. Here a tapestry-woven picture of a gnarled rock with bamboo adorns the centre uninterrupted. The picture is framed by different trimmings that follow the outline shape of the waistcoat.

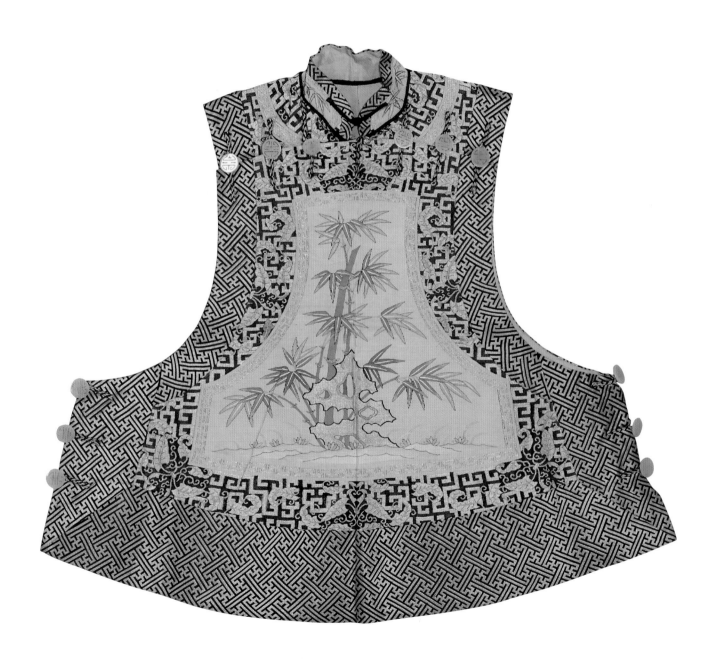

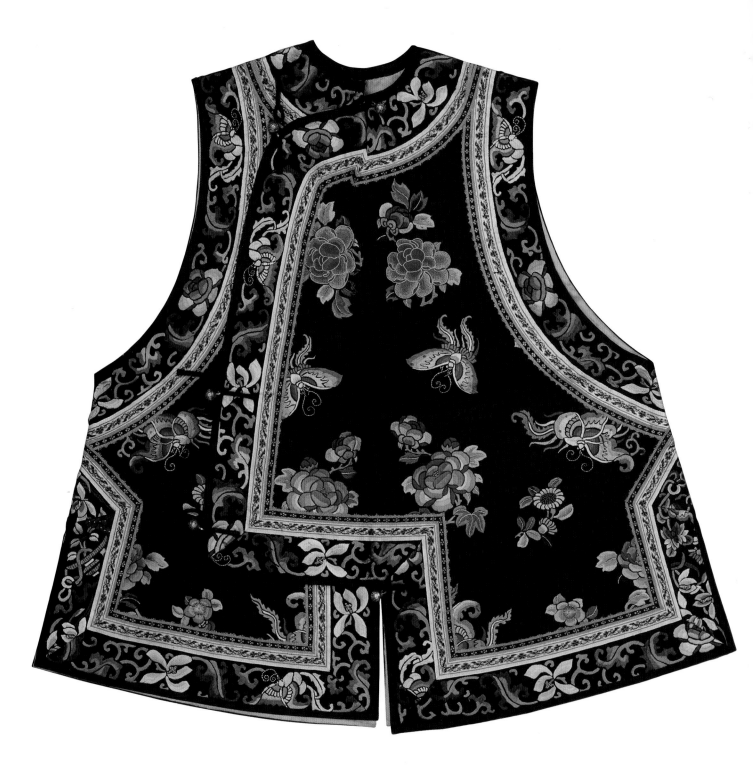

52. WOMAN'S INFORMAL SLEEVELESS WAISTCOAT (*JINSHEN*)
Dark blue satin with embroidered pattern
Tongzhi reign period (1862–74)
Gu44690

THIS SHORT SLEEVELESS WAISTCOAT is made of dark blue satin embellished with flowers and butterflies in red, pink and blue, narrow ribbon edgings, and a wider border of scrolling lotuses. The colour scheme of the border, known as the 'three blues' (*sanlan*), and the general layout, technique and design of the garment is seen time and again on ladies' clothing of the late nineteenth century.

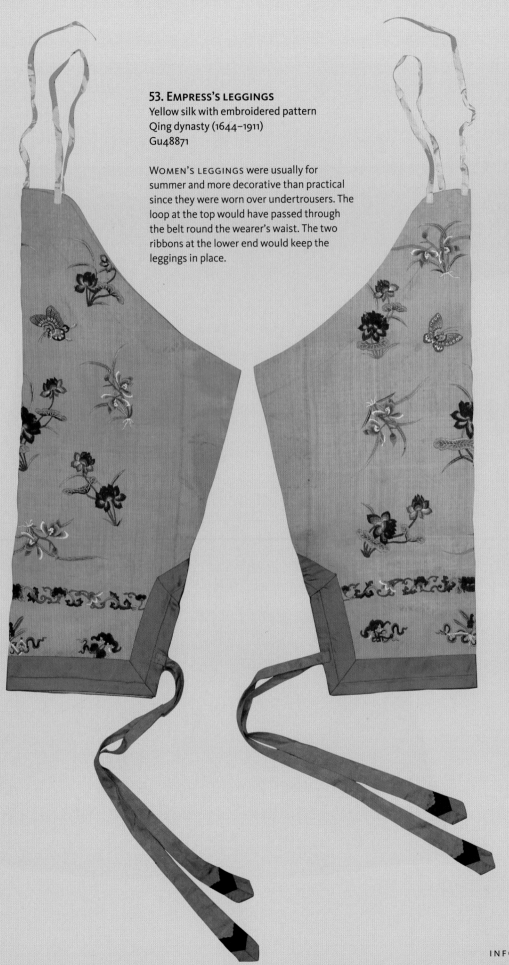

53. Empress's leggings
Yellow silk with embroidered pattern
Qing dynasty (1644–1911)
Gu48871

WOMEN'S LEGGINGS were usually for summer and more decorative than practical since they were worn over undertrousers. The loop at the top would have passed through the belt round the wearer's waist. The two ribbons at the lower end would keep the leggings in place.

MEN'S INFORMAL DRESS

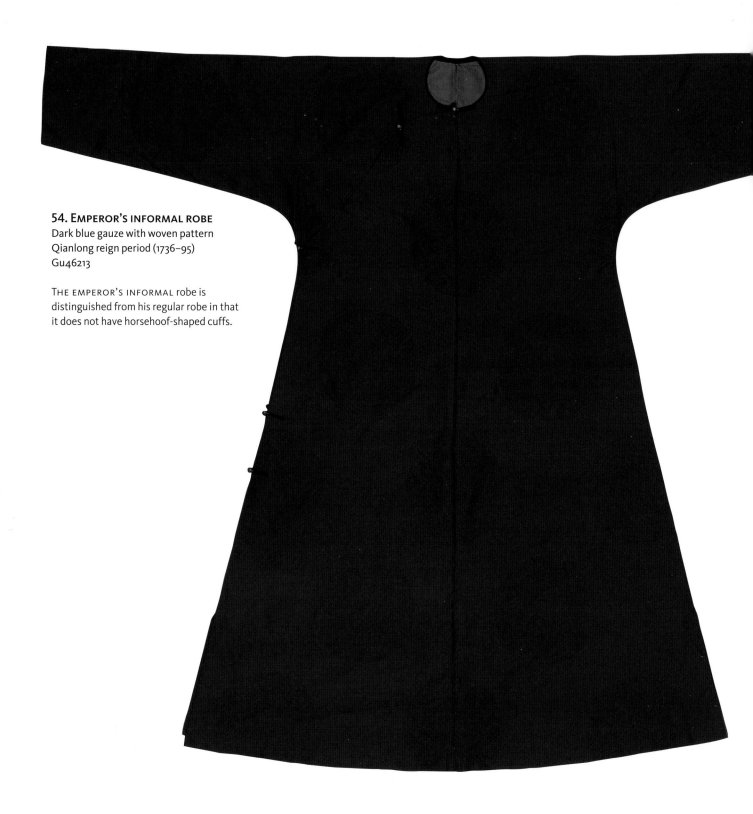

54. EMPEROR'S INFORMAL ROBE
Dark blue gauze with woven pattern
Qianlong reign period (1736–95)
Gu46213

THE EMPEROR'S INFORMAL robe is
distinguished from his regular robe in that
it does not have horsehoof-shaped cuffs.

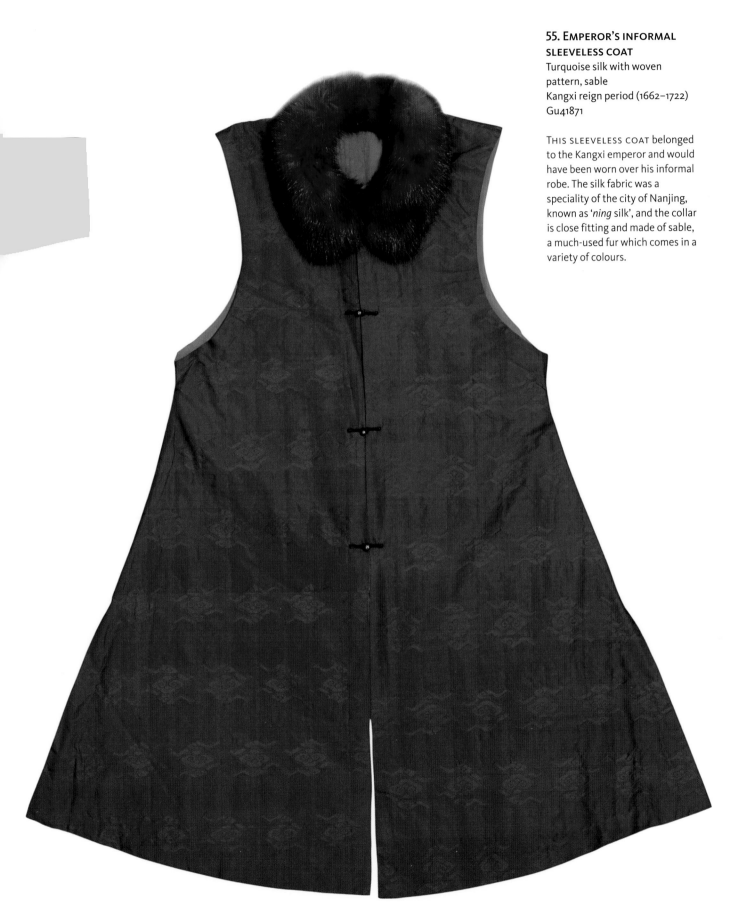

55. EMPEROR'S INFORMAL SLEEVELESS COAT
Turquoise silk with woven pattern, sable
Kangxi reign period (1662–1722)
Gu41871

THIS SLEEVELESS COAT belonged to the Kangxi emperor and would have been worn over his informal robe. The silk fabric was a speciality of the city of Nanjing, known as 'ning silk', and the collar is close fitting and made of sable, a much-used fur which comes in a variety of colours.

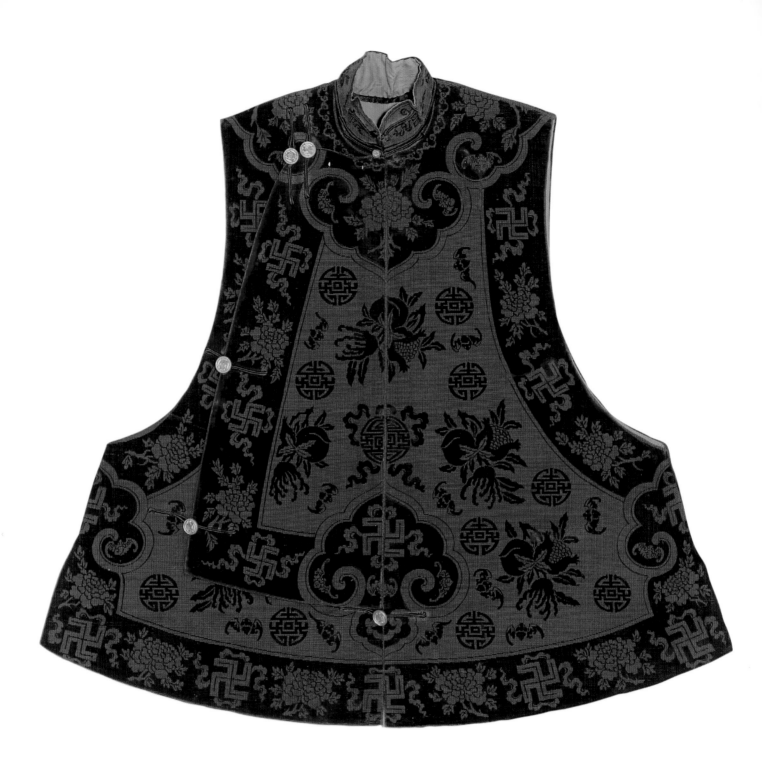

56. MAN'S INFORMAL SLEEVELESS WAISTCOAT (*JINSHEN*)

Burgundy patterned velvet
Late Qing dynasty (1862–1908)
Gu48092

THIS WAISTCOAT IS VERY MUCH a late Qing style, extremely popular in the nineteenth and early twentieth centuries and worn by both men and women. Its use was not confined to the imperial court and, like several other clothing shapes of the late Qing, it was widely worn by a range of Chinese people. The overlapping closure, the L-shaped *pipa* lappet, is a distinguishing characteristic of these garments. Deep sleeve openings, a high neck and the particular disposition of the buttons are also all notable hallmarks of this garment type. Instead of separately applied trimmings, the velvet is so woven as to incorporate the edgings as weaving progresses. The velvet therefore comes off the loom with the entire waistcoat patterning already delineated.

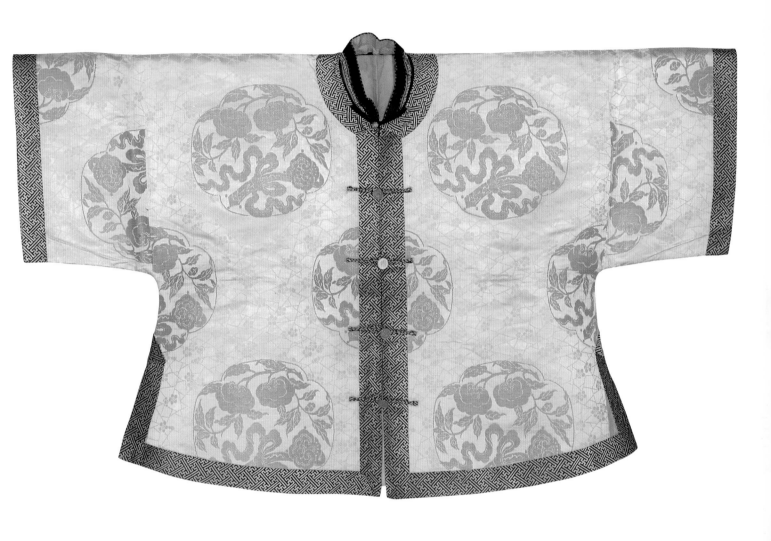

57. MAN'S PADDED RIDING JACKET (*MAGUA*)
Silver satin with woven pattern
Late Qing dynasty (1862–1908)
Gu48402

THE BACKGROUND DESIGN shows cracked ice and
prunus (plum blossom), and superimposed on this
are roundels enclosing persimmons and *ruyi*-
sceptres in gold thread. The visual effect is similar to
rays of sunlight shining on a pool of frozen water,
and demonstrates the technical virtuosity of the
weavers in the imperial silk mills.

58. EMPEROR'S TROUSERS
Yellow satin with woven pattern
Shunzhi reign period (1644–61)
Gu41677

THIS IS A RARE EXAMPLE of a garment from
the early years of the Qing dynasty when the
emperor's dress code was not yet formalized.
These trousers, which are most unlikely to
have been seen beneath the emperor's
layered ensembles, are pieced together from
several segments and have a high waist with
two sets of ties for fastening.

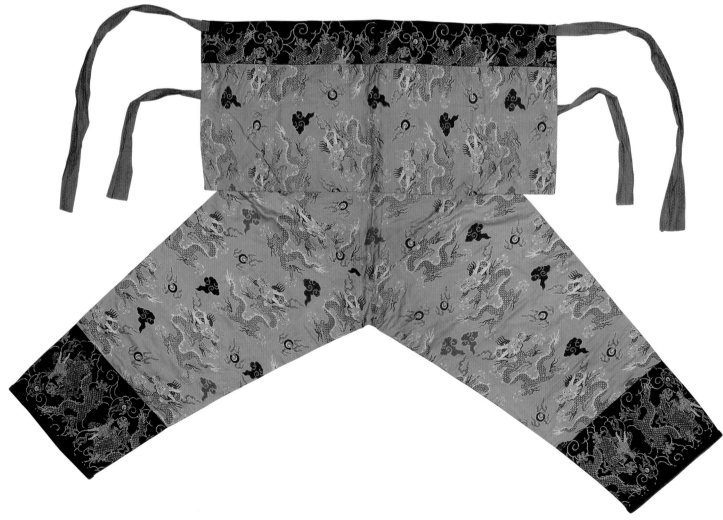

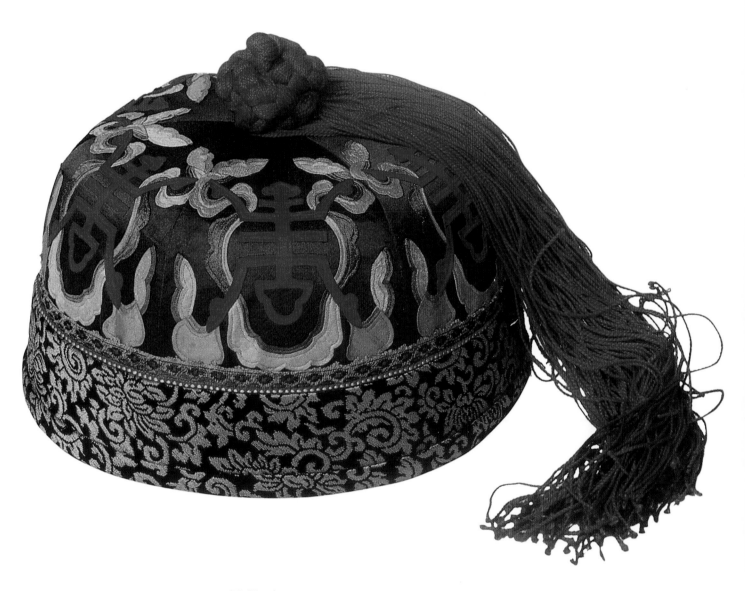

59. Man's informal cap
Blue satin with embroidered pattern,
red silk tassels
Guangxu reign period (1875–1908)
Gu59750

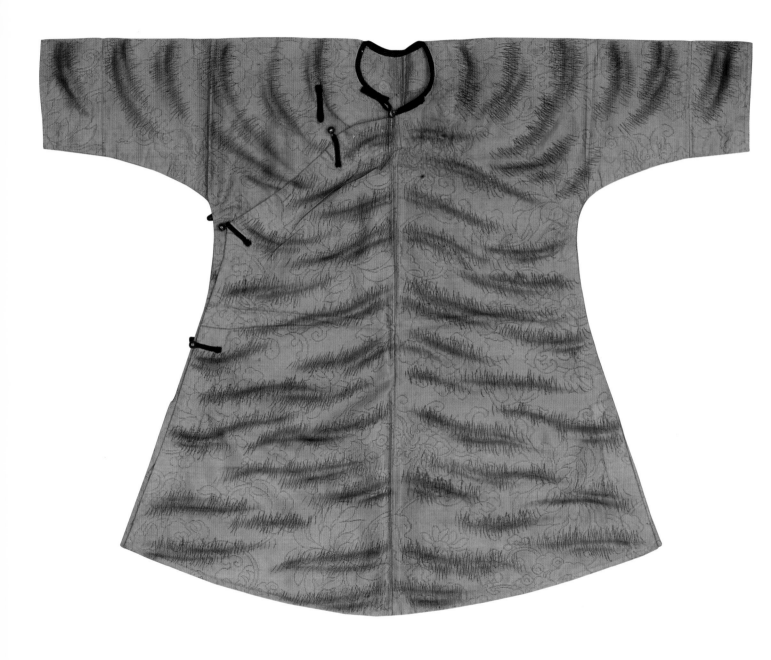

60. BOY EMPEROR'S INFORMAL ROBE AND LEGGINGS
Orange gauze with woven and painted patterns
Tongzhi reign period (1862–74)
Gu49269 and 49272

THE TONGZHI EMPEROR ascended the throne at the age of six, and this set of robe and leggings was a summer outfit for the boy emperor. The tiger-skin design is painted on the patterned gauze, a charming and unusual way to decorate a garment. Tiger motifs have always been popular for children's hats, shoes and collars; tigers chase away evil spirits and the word for tiger in Chinese sounds similar to that for wealth.

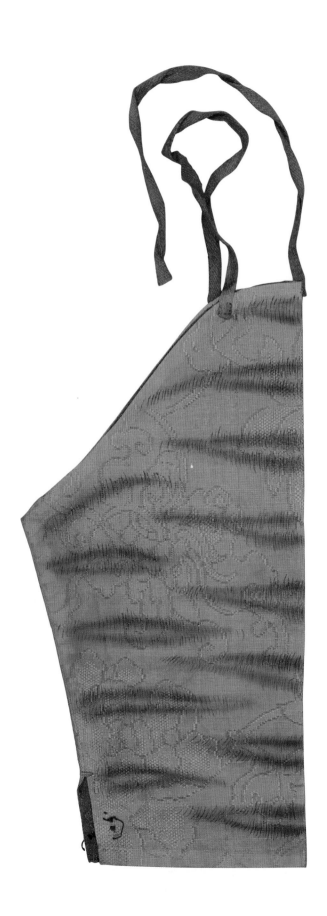
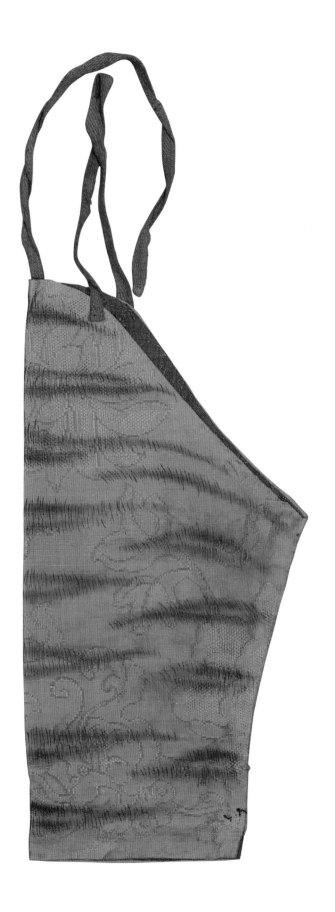

61. WOMAN'S SHOES
Satin, wood, starched white cotton
Kangxi reign period (1662–1722)
Gu60483

MANCHU WOMEN DID NOT bind
their feet and so their footwear is
distinct from the tiny shoes that
Han women adopted. The high
soles of Manchu shoes elevated the
wearer and the uppers were always
lavishly decorated. Here, the head
of the phoenix is rendered three
dimensionally, as if the bird is
perching on the shoes' tips.

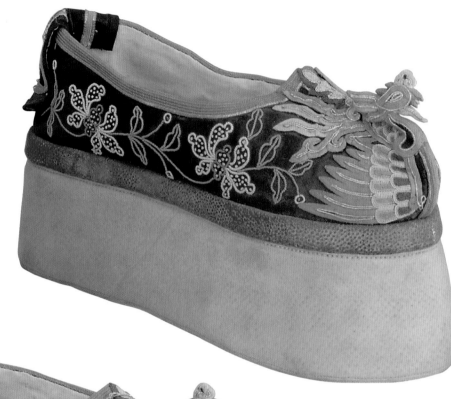

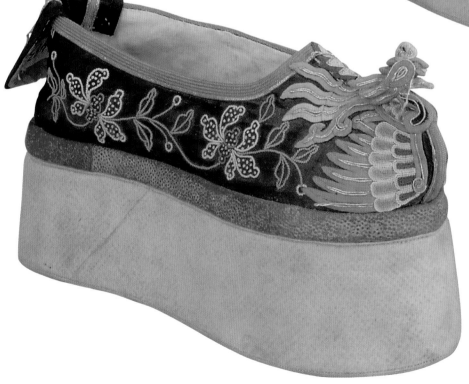

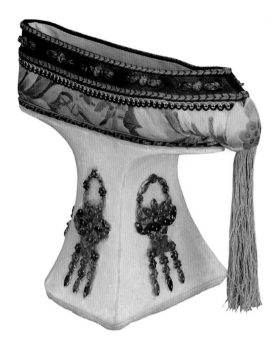 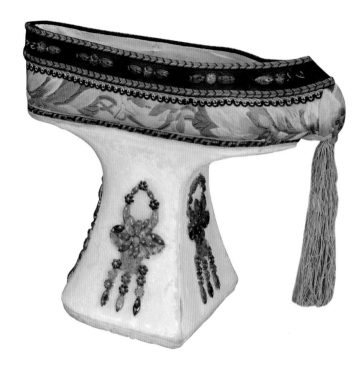

62. WOMAN'S SHOES (above)
Satin, wood, starched white cotton, glass beads, silk tassel
Guangxu reign period (1875–1908)
Gu61391

MANCHU WOMEN BELIEVED high shoes like these gave them
an attractive gait, though movement must have been severely
restricted by such footwear. Women of the Imperial Palace
were not required to walk long distances and their lives were
hedged about by rules and regulations. This particular style is
known as *huapandi* or 'flowerpot' because the platforms
resemble the shape of a Chinese flowerpot.

63. WOMAN'S SHOES (below)
Satin, wood, starched white cotton
Guangxu reign period (1875–1908)
Gu61052

MANCHU LADIES' SHOES are rarely seen in
pictures and photographs of the period.
Their robes just skimmed the ground and
usually hid their footwear. These shoes are
known as 'ingot shoes', as the platforms
resemble silver ingots used as currency in
China.

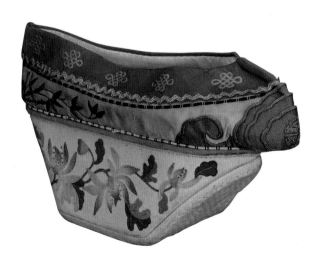 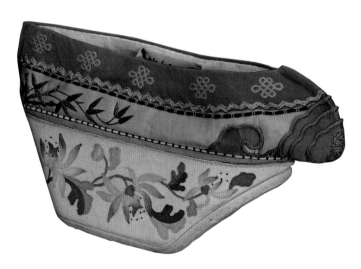

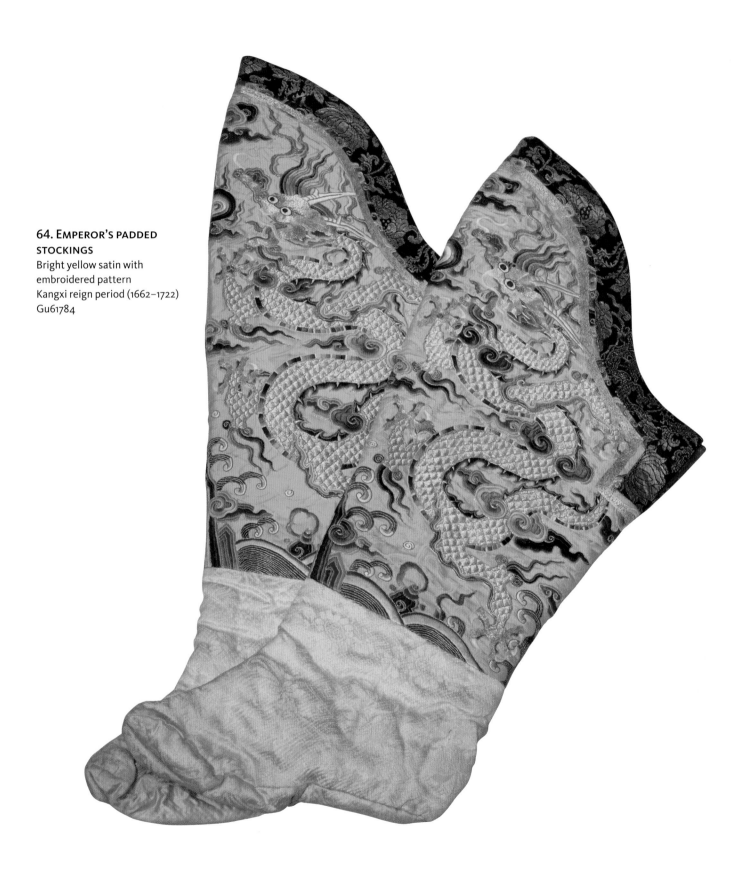

**64. Emperor's padded
stockings**
Bright yellow satin with
embroidered pattern
Kangxi reign period (1662–1722)
Gu61784

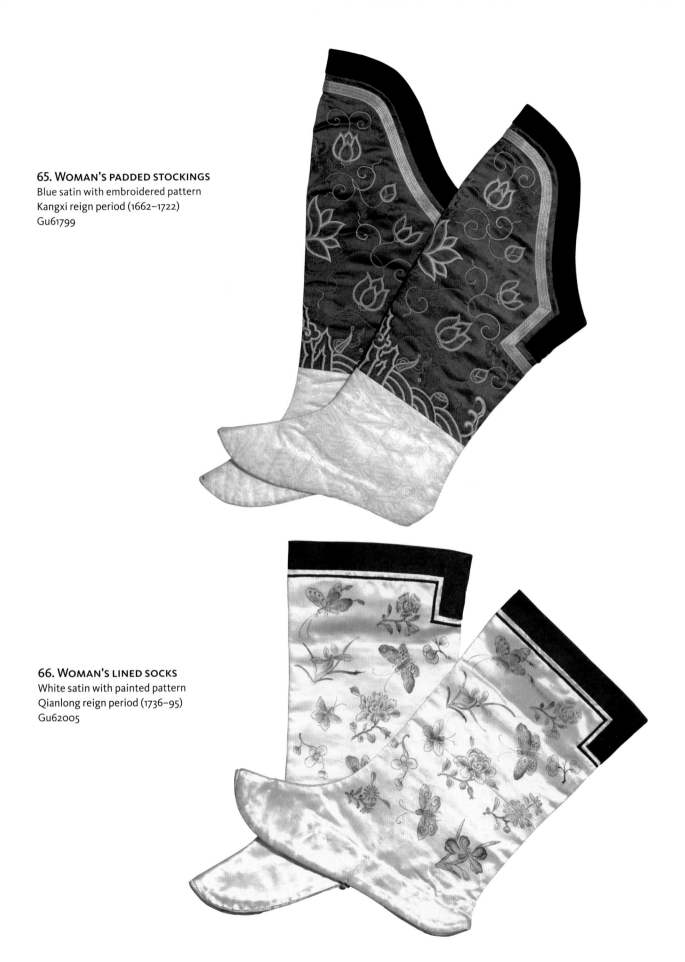

65. WOMAN'S PADDED STOCKINGS
Blue satin with embroidered pattern
Kangxi reign period (1662–1722)
Gu61799

66. WOMAN'S LINED SOCKS
White satin with painted pattern
Qianlong reign period (1736–95)
Gu62005

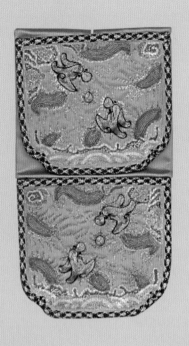

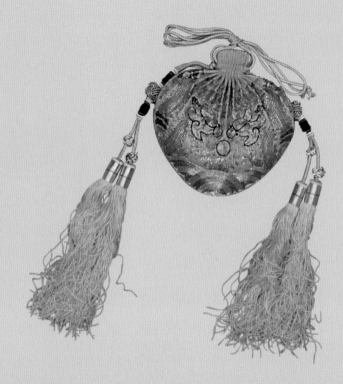

67. Emperor's purse set
Bright yellow satin with
embroidered patterns
Guangxu reign period (1875–1908)
Gu69382

This set of seven purses and
pouches would have been worn
suspended from a belt. It consists
of cases for a watch, thumb-ring,
spectacles, a fan, fire-lighting
tools and two purses.

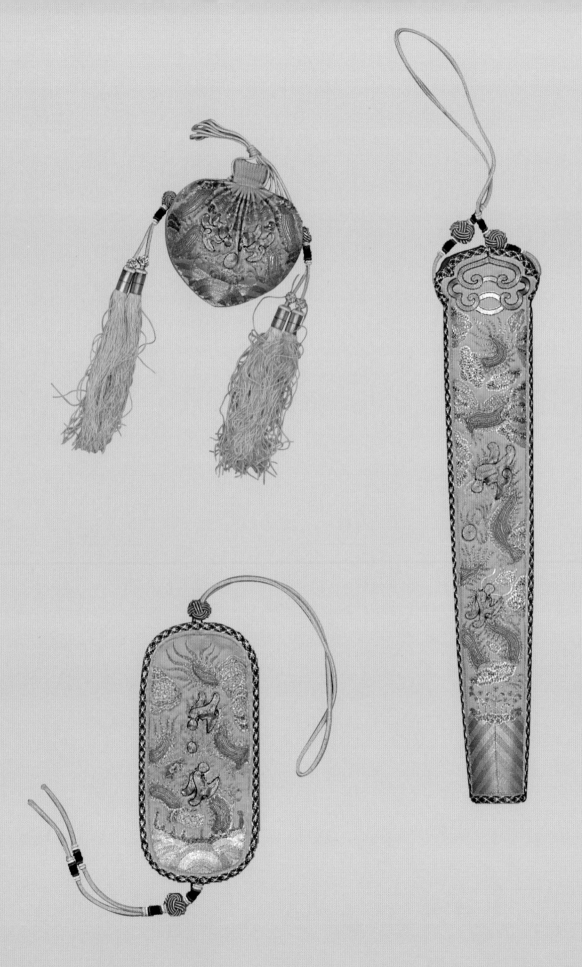

5. PRODUCTION PROCESSES AND IMPERIAL TEXTILE MANUFACTORIES

Yan Yong

THE IMPERIAL HOUSEHOLD Department, which served the emperor and the imperial household directly and exclusively, supervised and managed the production of clothing for the imperial family. The design of the formal dresses, however, was a matter of such importance that it came under the Board of Rites. Firstly, the Board of Rites decided the form of the dress, the material to use in its production, the colour, and the quantity required. Once the emperor had approved the design, court painters would draw the dress on paper in colour, accurately depicting the shape, the materials, the motifs, and the measurements of the garment. Next, the Imperial Household Department would send the graphic design to one of the three imperial textile manufactories in the three cities south of the Yangzi River: Nanjing (known as 'Jiangning' at that time), Suzhou and Hangzhou. The required textiles would be produced with strict adherence to the given specifications.

The Imperial Household Department was a sizeable department in charge of seven offices. It was headed by a state official of the second rank and its entire staff numbered more than 3,000. One of the seven offices was the Storage Office, under whose jurisdiction were the Six Storehouses – for hides, silks, clothing, silver, porcelain and tea. The Six Storehouses supervised seven workshops, five of which were responsible for dyeing, tailoring, embroidery, patterning and pelt sewing. Two smaller workrooms, one responsible for hats and one for haberdashery, were also managed by the Six Storehouses.

The Storage Office's main function was to safeguard and maintain quality control of clothing, jewellery and accessories, textiles, and other items needed by the emperor and the imperial court. As its name makes clear, the Silks Storehouse was responsible for the safekeeping of the various types of silks and fabrics sent to Beijing from other parts of the country. The Tailoring Workshop, the Embroidery Workshop and the Patterning Workshop all contributed towards the production of imperial dresses according to their specialization.

Over 3,400 designs of Qing imperial dresses and accessories have survived and are now in the Palace Museum collection. Many of them accord well with extant clothing items also in the Museum's collection. A detailed study of the designs can yield valuable information about the production processes involved. One example is the drawings of the front and back of a winter court robe, with the annotation that 'a robe to be made in bright yellow tapestry-woven silk, exactly as per the drawing'. Another drawing carries the annotation that 'this court robe is to have sea otter fur trimming, so sufficient fabric should be included for the fur trimming to be sewn on'. From this annotation we can deduce that the drawing was sent to one

textile manufactory in south China, but the fur trimming was added in the palace workshop. Therefore the Imperial Household Department had to tell the weaving mill to cut the finished fabric to the right measurements, taking into account the fur trimming.

The Three Textile Manufactories of Jiangnan, as they were commonly referred to by people in Beijing, were large-scale, large-capital organizations, with sophisticated division of labour and efficient management. According to the *History of the Suzhou Textile Manufactory*, the mill had 800 weaving looms and employed 2,602 weavers in 1685.[1] Heading the organization chart were the chief experts, experts and supervisors. Under them were section heads, in charge of warp and weft, filament-twisting, flat gold filaments, coloured pile, yardage counts and pattern books. Lastly came the craftsmen doing section-embroidery, pattern-layout, reverse-patterning, drying, cloth cutting, pattern drawing and cord making. Operators of a 'plain weave and patterned-weave loom' were also mentioned.[2]

Records of the Nanjing Manufactory refer to a number of specialized plant rooms. One of these made a kind of silk fabric used exclusively for writing imperial patents and ordinances, with the characters *fengtian gaoming* ('entrusted by Heaven, order of the Emperor') woven into the textile. At the Nanjing Manufactory the division of labour was even more detailed. Two types of craftsmen were needed for the preparation of the warp threads (longitudinal threads) alone, one to 'smooth the threads' and one to 'ensure unbroken threads'.

Each of the Three Manufactories had its own speciality products. The Nanjing Manufactory's principal product was brocaded silk. The weavers incorporated such a multitude of colours into one piece of textile that the fabric was known as 'cloud brocade' (*yunjin*). This was understood to mean that the beauty of the textile was comparable to colourful clouds at dawn or sunset. The Suzhou Manufactory was best known for its tapestry-weave silk (*kesi*) and its Song dynasty-style brocaded silk. Hangzhou specialized in plain-coloured fabrics and damasks with 'hidden' patterns. These subtle patterns were achieved using a thread very slightly darker or slightly lighter than the background colour of the fabric.

The annual output of the Three Manufactories was enormous. The textiles were graded 'top' or 'official', the former for the use of the emperor and members of his family, the latter to furnish the numerous halls and rooms in the Forbidden City, or given as diplomatic gifts. Records show that in 1662 the Hangzhou Manufactory produced 1,840 bolts of satin, plain weave silk, twill and gauze, all of top grade. In the same year it also produced 2,290 bolts of top-grade patterned satin, gold-threaded satin, brushed pile, damask on tabby and shot damask, bringing the total to 4,130 bolts.[3]

When the emperor made one of his regular tours to the provinces, the Manufactories did their utmost to impress him. In 1776 the Qianlong emperor (r. 1736–95) visited Shandong province. The supervisory official at the Suzhou Manufactory presented the Emperor with 360 pieces of assorted dress materials, sending another 360 pieces ten days later. The supervisory officials at the Hangzhou and Nanjing Manufactories followed suit. But their efforts were dwarfed by the performance of the Salt Commissioner, who offered gifts of 3,000 pieces followed by another 1,000 pieces within seven days. Presumably the officials paid for the textiles out of their own pockets, but the ability of the Three Manufactories to produce such quantity and variety within a relatively short period was remarkable nonetheless.

Since the imperial court was the major customer of the Three Manufactories, the products had to meet extremely high standards, and failings were severely punished. The Imperial Household Department records show repeated decrees from the emperors, stating that 'the warp and weft must be even, the length and width serviceable, the patterning delicate, and the colours vibrant'. Sub-standard

products would result in fines, salary reductions, and corporal punishments such as whipping.

In 1711 the Nanjing Manufactory was reprimanded because out of a delivery of 3,760 bolts, twelve were found to be defective. It escaped punishment but had to send replacement bolts.[4] In 1773 rules were established concerning defective goods. For top-grade silks, if there were more than three defective bolts in one delivery, the responsible supervisory official would be punished. For official-grade silks the threshold number of defective bolts was ten. Needless to say, all defective bolts had to be replaced at no extra charge.[5]

Sometimes an innocent article like satin had a role to play in political intrigue. In 1727 the Yongzheng emperor (r. 1723–35) noticed that the dark blue colour of his satin surcoat rubbed off. He demanded to know which mill had produced the satin, which supervisory official was responsible, and which eunuch was in charge. He further remarked: 'Of all the satin available in the storehouse why choose a non-colourfast piece? If the colour on all the satin in the storehouse comes off, it is the fault of the supervisory official. If there is colourfast satin in the storehouse, it is possible someone deliberately chose a non-colourfast piece to get the supervisory official into trouble. The Head of the Imperial Household Department must investigate this matter thoroughly.' Consequently, all the satin in the Silks Storehouse was checked bolt by bolt, and each bolt had defective colouring. The fabrics came from Nanjing, so the supervisory official at the Nanjing Manufactory had his salary suspended for a whole year, while the Silks Storehouse keeper was given fifty lashes.[6]

The Qianlong emperor was especially demanding, almost harsh, when it came to his own clothing, be it on a point of tailoring, material, colour or patterning. In 1744 he decreed that all assignments given to the Three Manufactories should undergo a process of quality control. When the textiles were delivered, they were to be examined by the Head of the Imperial Household Department. Products of particular importance should be presented for inspection by the emperor himself.

In 1747 he was not happy with two bolts of brocaded silk presented for approval by the Suzhou Manufactory, criticizing the colour as 'too dark'. The Suzhou Manufactory was ordered to weave new bolts. In 1756 he found fault with the length of his own robes, which were four feet, one and a half inches long, according to Chinese length. Declaring them to be 'too short', he ordered that his robes should be lengthened by one inch. Hardly six months had passed when he complained that the robes were 'too long'. He wanted them to be shortened by half an inch. The dressmakers from the Imperial Household Department could only yield to His Majesty's whims and obeyed his constant calls for modification.

Finished textiles and clothing items were couriered to the capital and delivered within strict time limits to the Silks Storehouse. They were then tailored, embroidered, and made into garments in the relevant workshops. To ensure accountability, each item would be marked with the names of the weaver, the supervisory official at the Manufactory, and the official who inspected and approved the finished product.

The Three Textile Manufactories of Jiangnan had brought together the finest textile workers in the country. Cost was never their concern and they could devote all their resources to creating exquisite materials of the very highest quality.

1 Sun Pei, p.17
2 Sun Pei, pp94–6
3 First National Archive Database, Inner Palace Miscellaneous Records, no.334
4 Palace Museum, pp93–4
5 *Collected Statutes and Precedents of the Great Qing*, chapter 1190, p.19
6 Palace Museum, pp181–2

FABRICS

68. BOLT OF BROCADED SATIN
Multi-coloured flowers, fruits and auspicious symbols on a green ground
Jiaqing reign period (1796–1820)
Width 76.5cm
Gu18105

THE FLOWER AND FRUIT PATTERN is generated by introducing supplementary weft yarns into the foundation weave. More than ten colours have been used, and a high level of skill would have been required to produce the pattern.

69. LENGTH OF BROCADED SATIN
Multi-coloured peonies and pomegranates on a blue ground
Jiaqing reign period (1796–1820)
Width 55cm
Gu17815

THIS IS A HIGHLY sophisticated weave. A flat gold thread and a wrapped gold thread are used to create the leaf design. The peonies are depicted in three shades of violet.

70. LENGTH OF BROCADED SATIN
Prunus and cracked ice design on a black ground
Kangxi reign period (1662–1722)
Width 76cm
Gu17807

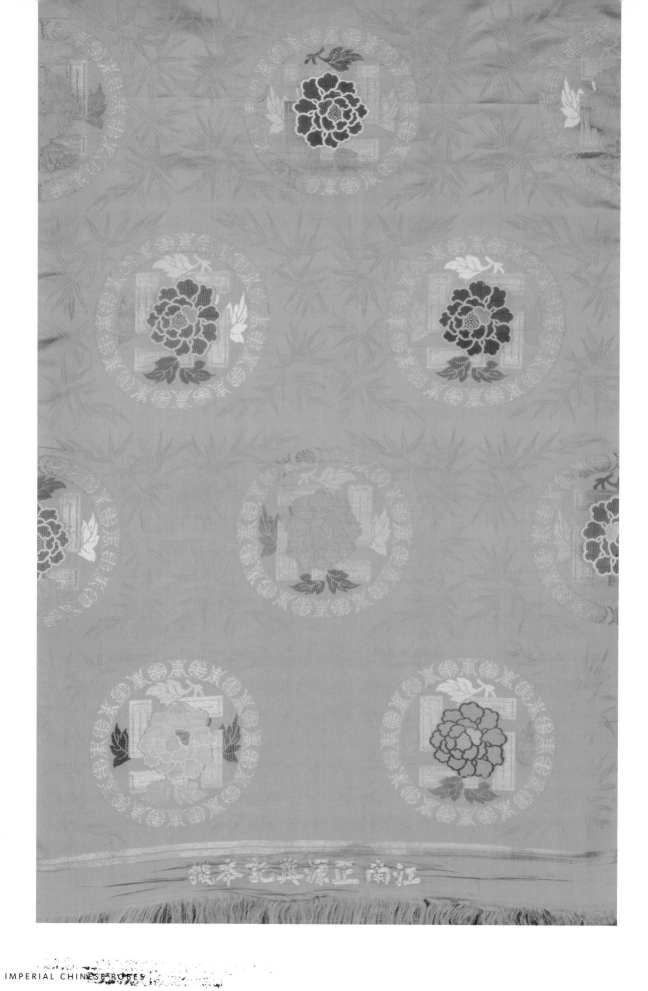

71. Length of brocaded damask

Multi-coloured peony and swastika roundels on a lilac patterned ground
Guangxu reign period (1875–1908)
Width 78.5cm
Gu17879

This material was intended for a woman's informal outer gown. The name of the weaving mill, 'Zhengyuan Xingji, Jiangnan' is inscribed on the loom end.

72. Length of gold brocaded satin

Hexagons and squares
Qianlong reign period (1736–95)
Width 76.5cm
Gu17945

Each hexagon encloses a dragon, and each square encloses the character *wan* ('myriad') or *shou* ('longevity'). Green, blue and red yarns have been subtly incorporated into the weave to provide variation to the predominant gold.

73. Length of red silk

Dragons among clouds in gold
Qianlong reign period (1736–95)
Width 78.4cm
Gu17923

Large amounts of gold thread made this fabric a luxury product.

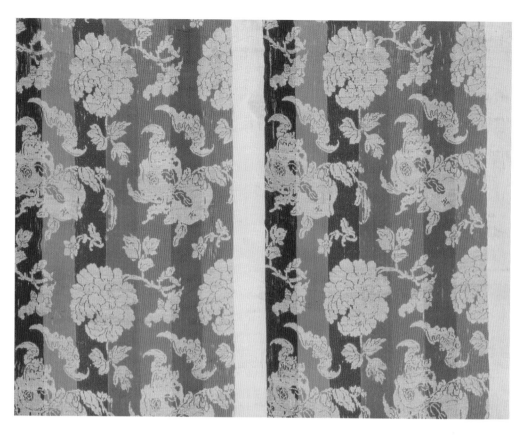

**74. LENGTH OF SICHUAN
BROCADE**
White flowers and fruits on a
multi-coloured striped
ground
Guangxu reign period
(1875–1908)
Width 72.5cm
Gu18522

THIS MATERIAL, a speciality of
Sichuan in west China, was
intended as a quilt cover.

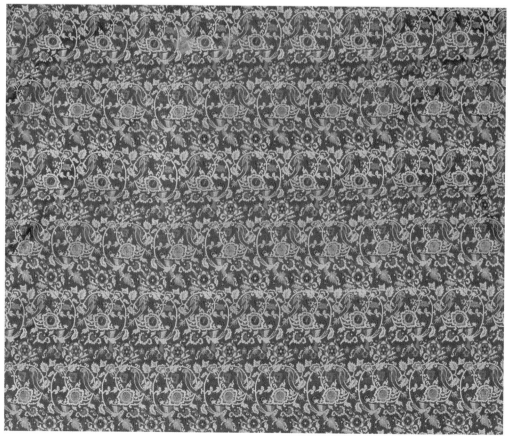

**75. BOLT OF GUANGDONG
PATTERNED SATIN**
Multi-coloured flowers and
birds on a green ground
Qing dynasty (1644–1911)
Width 74cm
Gu18131

GUANGDONG IN SOUTH
CHINA, some way from the
imperial manufactories in the
Lower Yangzi valley, was
another production centre for
this type of textile.

76. LENGTH OF PATTERNED VELVET
Chrysanthemums within a diamond fret
on a green ground
Qianlong reign period (1736–95)
Width 60.3cm
Gu22765

THIS IS AN EXAMPLE of patterned velvet
on a plain velvet ground. It was an ideal
material for furnishings.

77. LENGTH OF VELVET
Multi-coloured peony design in velvet
on a blue ground
Qianlong reign period (1736–95)
Width 74cm
Gu23146

ZHANGZHOU IN SOUTH CHINA was the
first city to produce velvet. Subsequently,
many velvets were called 'Zhang velvet'
regardless of their place of manufacture.
There were two main types produced in
China at this time: velvet on a satin
ground as here, or patterned velvet on a
plain velvet ground as plate 76.

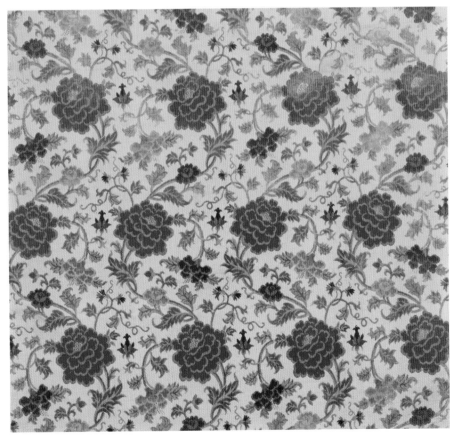

78. LENGTH OF 'MASHILU' VELVET
Multi-coloured geometric design on a
dark ground
Qianlong reign period (1736–95)
Width 41.8cm
Gu19619

'MASHILU' IS AN eighteenth-century
Chinese transliteration of the Uyghur
word for 'silk cloth'. It is a kind of velvet
produced by the Uyghur people in the
city of Hetian in present-day Xinjiang
province. The slightly blurred geometric
pattern was achieved by using pre-dyed
yarns as warp threads.

79. LENGTH OF 'WESTERN' PATTERNED SILK
Pink roses on a beige ground
Late Qing dynasty (1862–1908)
Width 70.5cm
Gu18411

THIS SILK WAS WOVEN on an imported western loom, a novelty at the time. The mechanized apparatus caught the Chinese fancy because it was markedly different from the manual wooden Chinese loom.

80. LENGTH OF 'WESTERN' GAUZE
Blue peonies on a white ground
Late Qing dynasty (1862–1908)
Width 57cm
Gu21162

Multi-coloured floral design
1700–1750
Width 62cm
Gu18676

THIS LENGTH OF SILK was
sent to the Qing court as a
tribute by the Uyghur people
of northwest China. Uyghurs
are followers of Islam, and so
the brocaded silk was known
as 'Mohammedan' fabric. It
actually came from Safavid
Iran and must have reached
the Uyghurs via the Silk
Route.

82. UNCUT FABRIC FOR A FESTIVE ROBE
Red silk with embroidered pattern
Jiaqing reign period (1796–1820)
Width 152cm
Gu29643

THIS PIECE SHOWS how imperial robes were produced. The red silk background fabric was woven in one of the three imperial textile manufactories. It was then sent to the capital, Beijing, where the lengths of silk were sewn together and the design painted onto the silk, across the front vertical seam. The fabric was then stretched between frames for embroidering. The final stage was the tailoring of the garment shape itself and other finishing details at the palace workshop.

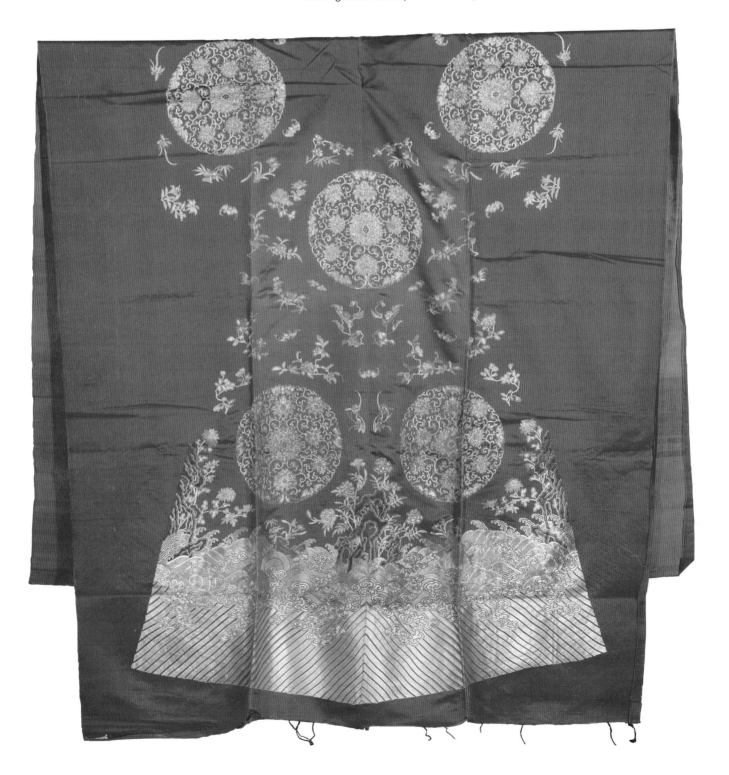

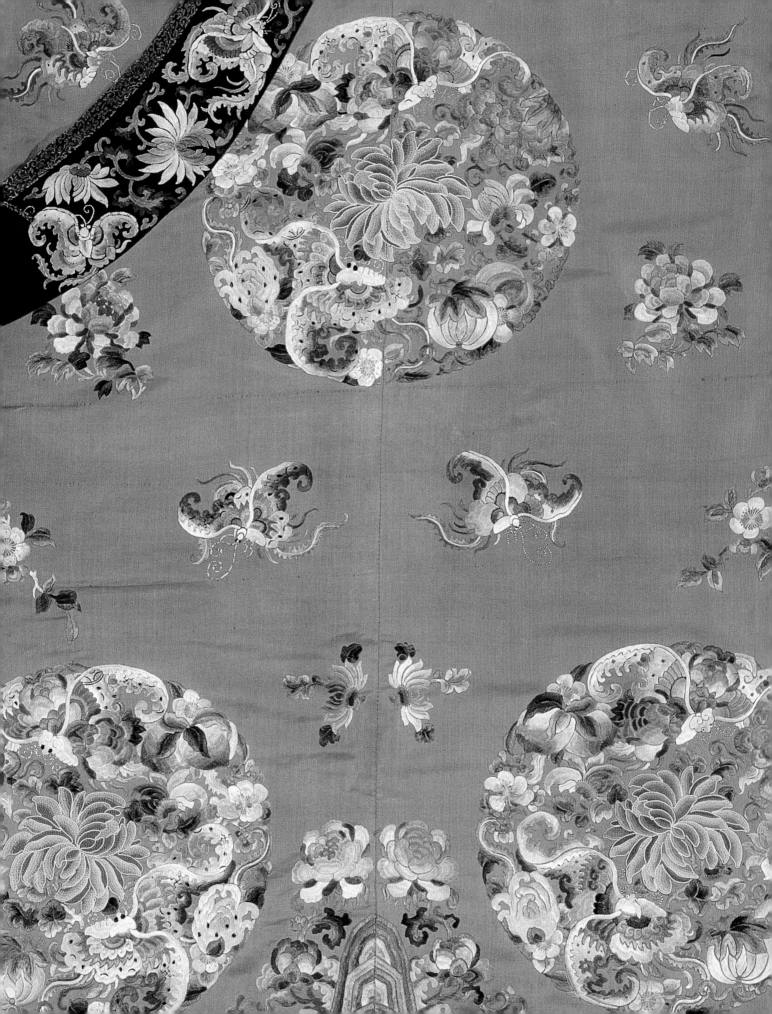

6. EPILOGUE:
WHAT IS AN 'IMPERIAL' ROBE?

Ming Wilson

For many centuries, both the dragon motif in different forms and a particular bright yellow colour were reserved solely for use in the emperor's garments. Chinese people knew the penalty too well to dare break the law and incorporate them in their own clothes. To the people of Victorian Britain especially, the 'dragon robe' had an exotic appeal; it represented a mysterious, far-off land whose customs and way of life were totally different from their own. Since the time of the First Opium War (1840–42), there had been numerous opportunities for British people to acquire one or more dragon robes. When those robes became the object of scholarly study in the twentieth century, the most frequently asked question was whether the robes were indeed 'imperial', or whether they were articles produced to satisfy a curious, but uninformed, clientele.

Perhaps the best place to begin is with the term 'dragon robe'. In Chinese, two terms are used for the creature on these robes: '*long*' and '*mang*'. What was generally called a 'dragon robe' in Britain was not necessarily the same as the 'dragon robe' mentioned in the Forbidden City records. To an English-speaking observer, the robe depicted on an illustrated manuscript now in the Victoria and Albert Museum (fig. 8) is a 'dragon robe', but the Chinese caption calls the

Fig. 8: Drawing of a *mang* robe for a prince.
V&A: D.1946–1900

garment a 'mang' robe for the emperor's sons. Since both the dragon and the mang are mythical creatures, and indeed often seem to be identical, it would be pointless to try to describe either a dragon or a mang. It may only be the rank of their wearer that defines the robes as either 'long' or 'mang'. One robe in the collection of the V&A (fig. 9) is described in the Museum's records as 'dragon robe'. To a Chinese historian it is a 'mang' robe because it has a blue background and so was for a nobleman of lower rank.

The dragon robe, or the mang robe, could be worn by a woman as well as a man. A woman's robe differed little from a man's in terms of shape and cut. A bright yellow robe in the V&A (fig. 10), with red double-happiness characters, was for an empress or imperial concubine of the first rank due to its colour. The double-happiness characters point to the female identity of the wearer because this motif was not one used on men's clothes. Further, this robe has an extra pair of sleevebands at elbow level and there is no slit in the centre front, both marks of women's garments.

Since the dragon robe had such a strong appeal to Westerners, there remains the possibility that many of the robes were sold to them by enterprising merchants at the turn of the twentieth century. The Qing dynasty was crumbling, and the imperial weaving mills that had supplied dress materials to the court and other noblemen for centuries would not have hesitated to sell a few dragon robes or mang robes to keen Western buyers. The robe with yellow sleeves (fig. 11) is probably one such product made shortly before or after 1911, when imperial China ceased to exist. The material is tapestry-weave silk (kesi), a laborious technique and thus expensive. The two sections of yellow satin above the cuffs are totally incongruous with the overall colour scheme of the robe, and perhaps on account of this it was deemed fit for disposal to a Westerner.

Westerners were so attracted to the dragon robe that they overlooked the court robe which in fact ranked highest in the Chinese dress hierarchy. It may well be that the court robe was not so readily available as the dragon robe. A few court robes that reached Britain were genuine imperial objects. The one in the V&A collection (fig. 12) is correctly embroidered with the Twelve Symbols, but the matching shoulder cape is missing. It is unclear under what circumstances the robe left the Forbidden City.

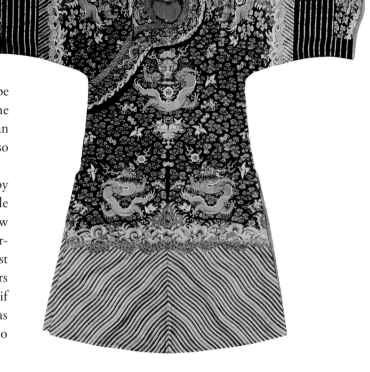

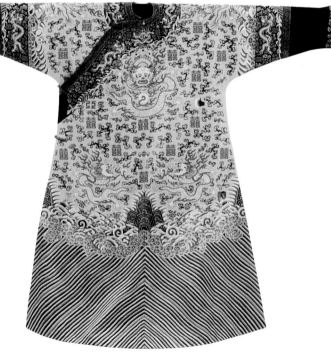

Fig. 9 (above)
Nobleman's mang robe
V&A: T.219–1948

Fig. 10 (below)
Empress's festive robe
V&A: T.253–1967

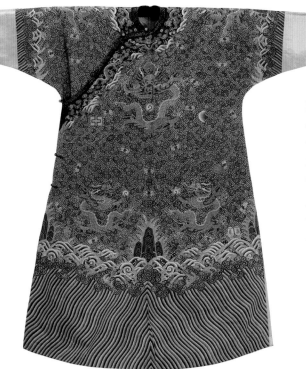

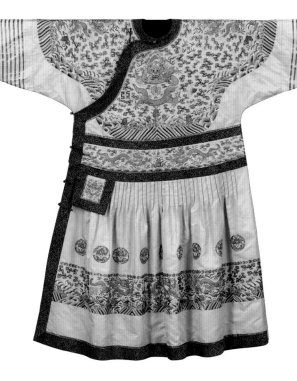

A robe with a subtle dragon pattern (fig. 13) is not considered a dragon robe. Yet this simpler garment, made of golden yellow satin with dragon roundels, accords extremely well with other robes that once belonged to the Qian-long emperor. They were 'regular robes', worn by him on ordinary occasions. The dragon roundels on the V&A robe, though inconspicuous, are beautifully woven, while the silk is soft and supple to the touch. This type of subtle elegance was a hallmark of imperial production. It can never be proven that an emperor once wore the V&A robe, however its quality is certainly as good as any robe in the Palace Museum collection.

Imperial ownership of female dresses, especially dresses made after 1850, is even more difficult to establish. The festive robe was formal wear for women, ranging from the empress at the top of the social hierarchy down through the rankings. Female festive robes were embellished either with the *mang* motif or, more frequently, a floral pattern, such as the turquoise-coloured robe in the V&A collection (fig. 14). The coloured 'standing water' motif at the hem indicates that the robe was a formal dress. The Qing clothing regulations made no mention of female festive robes with floral patterns. If a robe is not of the yellow colour, the social status of its wearer cannot be established with certainty. Workmanship might provide some clues: for example, the embroidery on the turquoise-coloured robe is very intricate and would have been labour-intensive and so perhaps expensive to produce. We can only speculate that this quality of robe would have been beyond the reach of low-ranking officials.

Some garments were worn by imperial family members and commoners alike, the informal outer gown (*changyi*) being one such example. Stylistically, the bright blue outer gown in the V&A collection (fig. 15) is very similar to plate 44. Both have long slits at the sides, while the wide borders have a pattern that matches the main fabric but are in contrasting colours. The difference lies in the details. The yellow gown, which was for the empress or the empress dowager, is embellished with two additional trims, a feature lacking on the blue gown. It can also be argued that the tailoring of the yellow gown is better.

On the subject of silk fabric, palace records show that the Qing court was supplied by the Three Textile Manufactories of Jiangnan (see Chapter 5). However there were hundreds

Fig.11 (above)
Nobleman's *mang* robe
V&A: T.199–1948

Fig. 12 (below)
Emperor's court robe
V&A: T.753–1950

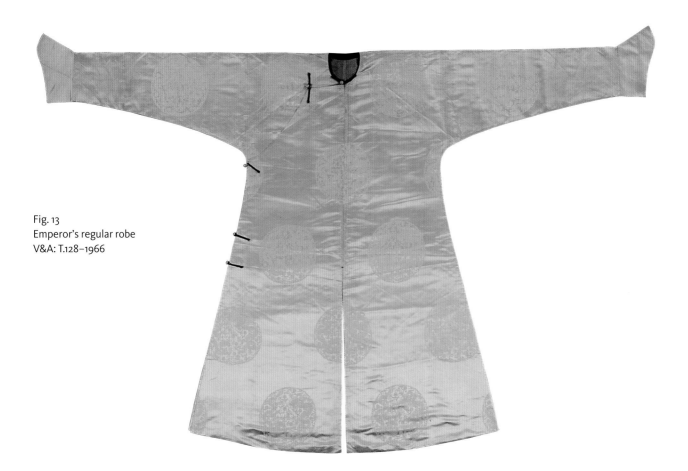

Fig. 13
Emperor's regular robe
V&A: T.128–1966

of weaving mills in the Jiangnan area, and products from those non-imperial mills were not necessarily of inferior quality. Commoners were prohibited to wear the bright yellow colour and the dragon motif, but they were free to use the finest quality of silk as long as they could pay the price.

Textiles from the imperial mills sometimes came into the possession of commoners and foreigners. It was standard practice for emperors to give away bolts of silk as diplomatic gifts or as tokens of favour to his subjects, and the recipients of such imperial presents were at liberty to dispose of the silks in whatever manner they chose.

The palace archive gives detailed listings of presents given to members of the first British embassy by the Qianlong emperor in 1793.[1] The King of England was given objects made of cloisonné enamel, jade, porcelain, lacquer and silk. A breakdown of the last category is as follows:

Satin with dragon pattern	6 bolts
Satin with *mang* pattern	4 bolts
Brocade	14 bolts
Hundred-flower brocade	14 bolts
Patterned velvet	6 bolts
Gold-thread satin	4 bolts
Shot damask	8 bolts
Dark blue satin	4 bolts
Blue satin	8 bolts
Polychrome satin	8 bolts
Satin for making hats	8 bolts
Twill weave silk	44 bolts
Silk gauze	26 bolts
Silks of sundry descriptions	94 bolts

The ambassador, Lord George Macartney, and deputy ambassador, Sir George Staunton, received the same categories of silk, but in reduced quantity. It is surprising to note that the dragon pattern, in theory reserved for only four or five persons in the entire empire, was given to foreigners so liberally.

The recipients, on the other hand, left no records to indicate how they valued the dragon-patterned satin. Macartney was probably not as interested in the silk's imperial associations as he was in its potential as a commodity and future item of trade. The height of British fascination with Chinese imperial robes came later, at a time when China could not claim to be the most powerful empire in the world.

1 First National Archive 1996, pp.96–101

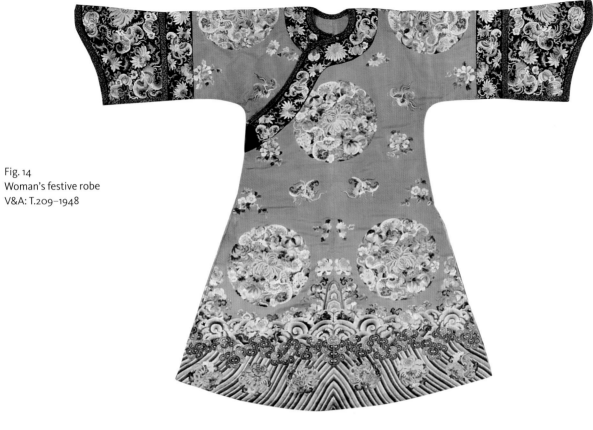

Fig. 14
Woman's festive robe
V&A: T.209–1948

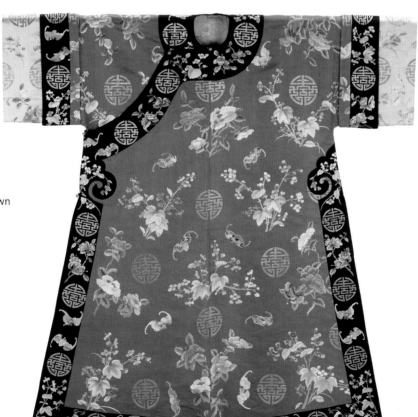

Fig. 15
Woman's informal outer gown
V&A: T.231–1948

EMPERORS
OF THE QING DYNASTY

THE FOUNDING FATHERS

Nurgaci	(ruled) 1616–26

Hong Taiji	1627–43

THE EMPERORS

Shunzhi	1644–61

Kangxi	1662–1722
	1700s Building of the Yuanming Yuan (Summer Palace) begins
	1710s Jesuit priests work in Chinese court

Yongzheng	1723–35
	1730 The English East India Company sets up trading post in Canton

Qianlong	1736–95
	1757 China restricts all trade with Europe to Canton
	1793 First British embassy to China

Jiaqing	1796–1820

Daoguang	1821–50
	1840 First Opium War. China tries to restrict the British opium trade

Xianfeng	1851–61
	1860 Second Opium War. Anglo-French troops burn the Summer Palace

Tongzhi	1862–74
	Empress Dowager Cixi wields power on behalf of Tongzhi and Guangxu until 1908

Guangxu	1875–1908
	1900 The Boxer Rebellion. Foreign troops put down the rebellion and loot the Forbidden City

Xuantong	1909–11
	1912 The Republic of China is established

BIBLIOGRAPHY

IN ENGLISH

Schuyler Cammann, *China's Dragon Robes* (New York, 1952, reprinted Chicago, n.d.)

Valery M. Garrett, *Chinese Clothing: An Illustrated Guide* (Hong Kong, 1994)

Valery M. Garrett, *Chinese Dress: From the Qing Dynasty to the Present* (Tuttle USA, 2008)

Evelyn S. Rawski and Jessica Rawson, eds, *China: The Three Emperors 1662-1795* (Royal Academy of Arts, exhib. cat., 2005)

A.C. Scott, *Chinese Costume in Transition* (Singapore, 1958)

Verity Wilson, *Chinese Dress in the Victoria and Albert Museum* (London, 1986, revised edition, 1990)

Zhang Hongxing, *The Qianlong Emperor: Treasures from the Forbidden City* (National Museums of Scotland, exhib. cat., 2002)

IN CHINESE

China Social Science Academy Economics Research Institute archive

Collected Statutes and Precedents of the Great Qing (Da qing hui dian shi li), 1899 lithograph edition

First National Archive of China, *Database of Qing dynasty archival documents (Qing dai dang an wen xian shu ju ku)*

First National Archive of China, *Collected documents on British ambassador Macartney's visit to China (Ying shi Ma Ga Er Ni fang hua dang an shi liao hui bian)* (Beijing, 1996)

Palace Archive, *Records of the Imperial Household Department Workshops (Nei wu fu zao ban chu ge zuo cheng zuo huo ji qing dang)*

Palace Museum, *Documents on the Cao Family of the Jiangning Weaving Mill (Guan yu Jiangning zhi zao Cao jia dang an shi liao)* (Zhonghua Shuju, 1975)

Qin Guojing and Yuan Hongqi, *Imperial life in the Forbidden City (Zi jin cheng huang jia sheng huo)*, (Beijing, 2006)

Sun Pei, *History of the Suzhou Textile Manufactory (Suzhou zhi zao ju zhi)* (Jiangsu renmin chubanshe, 1959)

ACKNOWLEDGEMENTS

THE BOARD OF TRUSTEES OF THE V&A wishes to express its appreciation for the generosity of the Palace Museum Beijing in making possible this exhibition. The V&A is proud of this close collaboration and is indebted to the Palace Museum's curators for making available their scholarly research on these objects, and to their conservators for preparing the exhibits, many of which are on show for the first time outside China.

Special thanks go to Dora Yuan and Yang Fan, Foreign Affairs Department, for coordinating all aspects of the exhibition in the most efficient manner.

The curator also acknowledges the assistance of Verity Wilson, a former colleague of the V&A and renowned specialist in Chinese textiles. Her expertise on the subject has substantially enriched this publication.

The exhibition was made possible with the kind support of Lady Keswick and Sir David Tang.